**Out of Breath**

## Forerunners: Ideas First

Short books of thought-in-process scholarship, where intense analysis, questioning, and speculation take the lead

FROM THE UNIVERSITY OF MINNESOTA PRESS

Claudia Milian
**LatinX**

Aaron Jaffe
**Spoiler Alert: A Critical Guide**

Don Ihde
**Medical Technics**

Jonathan Beecher Field
**Town Hall Meetings and the Death of Deliberation**

Jennifer Gabrys
**How to Do Things with Sensors**

Naa Oyo A. Kwate
**Burgers in Blackface: Anti-Black Restaurants Then and Now**

Arne De Boever
**Against Aesthetic Exceptionalism**

Steve Mentz
**Break Up the Anthropocene**

John Protevi
**Edges of the State**

Matthew J. Wolf-Meyer
**Theory for the World to Come: Speculative Fiction and Apocalyptic Anthropology**

Nicholas Tampio
**Learning versus the Common Core**

Kathryn Yusoff
**A Billion Black Anthropocenes or None**

Kenneth J. Saltman
**The Swindle of Innovative Educational Finance**

Ginger Nolan
**The Neocolonialism of the Global Village**

Joanna Zylinska
**The End of Man: A Feminist Counterapocalypse**

Robert Rosenberger
**Callous Objects: Designs against the Homeless**

William E. Connolly
**Aspirational Fascism: The Struggle for Multifaceted Democracy under Trumpism**

*(Continued on page 82)*

# Out of Breath
Vulnerability of Air in
Contemporary Art

Caterina Albano

*University of Minnesota Press*
MINNEAPOLIS
LONDON

ISBN 978-1-5179-1355-7 (PB)
ISBN 978-1-4529-6737-0 (Ebook)
ISBN 978-1-4529-6819-3 (Manifold)

Published by the University of Minnesota Press
111 Third Avenue South, Suite 290
Minneapolis, MN 55401-2520
http://www.upress.umn.edu

Available as a Manifold edition at manifold.umn.edu

The University of Minnesota is an equal-opportunity educator and employer.

# Contents

# Preface

In each breath we take there are two gifts.
The air that fills our lungs prolongs life.
Giving that air back to the world refreshes the soul.
For each one of these Gifts, each time we receive it,
We must give thanks.

THESE VERSES are both a complement to and an inspiration for Hossein Valamanesh's sculpture *Breath* (2013).[1] Made of delicate tree branches cast in bronze and arranged in the shape of a pair of lungs, Valamanesh's *Breath* evokes the intrinsic relation of life to air and breathing. It also alludes to the symbiotic organic and discursive connections that air and breathing establish between one who breathes and their surrounding environment. Such relations are at the core of this book, which focuses on breath and on what it means to breathe, especially when breathing is encroached upon by the forces that dominate the environments in which we live, be they pollution, economics, politics, violence, or infection. Hence, this book is also about the vulnerability of both air and breath.

I have been interested in the breath for a number of years, though this book began in the spring of 2020 during the Sars-CoV-2 pandemic, based on a 2019 paper I presented at the conference Art

---

1. Extract from Saadi's *Gulistan,* 1259 AD, Shiraz, Iran. These verses were included in the press release for Hossein Valamanesh's *Breath,* 2013, bronze, http://www.roseissa.com/past%20exhib/Hossein/Hossein-exh1.html.

and the Anthropocene in Dublin; it was written almost entirely during the United Kingdom's second and third national lockdowns in London where I live, and further revised in June 2021. Occasional references in the chapters record these different stages. The Sars-CoV-2 pandemic has brought to the fore many of the issues around air toxicity and harm to breathing that are central to my analysis. However, the pandemic itself can be linked to the precarity of air and what can be regarded as endemic breathlessness—whether in terms of poor air quality, ecological violence and conflict, or the policing of bodies through the control of air. In this sense, *Out of Breath* is part of the growing interest in air and breath across the arts and humanities, social and medical sciences, legal studies and activism. Perhaps what this book demonstrates, as a result of the Sars-CoV-2 pandemic, is the critical and affective significance of breathing and of the gaseous environments in which we live. The latter are, at the same time, physical, discursive, and ideological. They relate to the intersecting of ecology, economics, and politics, and to the interweaving of social and cultural conditions and practices with ingrained histories and their present articulations. Breathing is both a response to and a manifestation of such atmospheres. We breathe the air in which we are immersed; we breathe its matter, its information, and its emotional charge. We also share the air in which we are immersed, exhaling our own internal atmospheres. Through breathing, we both affect and are affected by air and what air is made of and represents. In trying throughout to engage critically with these entangled relations and their complexities while maintaining an attention to the embodied breath, I address themes as diverse as the ethics of breathing, air ecology and violations of air, toxicity and the politics of breathing, and the vulnerability of breath itself.

Guiding my analysis is a consideration of artistic practices. According to Chantal Mouffe, "There is an aesthetic dimension in the political and there is a political dimension in art."[2] Artistic prac-

2. Chantal Mouffe, *Agonistics: Thinking the World Politically* (London: Verso, 2013), 91.

tices have, in other words, the potential to critique and challenge today's atmospheres of breathing. All the artworks I consider are critical practices, if not overt practices of resistance. They engage reflectively with the ethics, ecologies, and politics of breathing by rendering visible what physical and metaphorical toxic clouds obfuscate (to refer to one of the works I examine) but also by mobilizing affect in drawing attention to breathing in its physical, psychological, and figurative inflections. Rather than including images in the text, I provide links to the artworks themselves, whenever possible, so that works can be accessed, at least partly, through online images, clips, or documentation.

The book is organized into four chapters. The first chapter focuses on the ethics of breathing as embodied and performative. The second deals with air pollution and toxicity, addressing issues of visibility and arguing for an ethics of breathing in terms of being and action. Here I also introduce the Sars-CoV-2 pandemic through a consideration of its implications for breathing and what breathing signifies. The third chapter examines air contamination through an analysis of radioactive contamination as a blueprint for other abuses of air. The chapter addresses forms of knowledge production at the intersecting of historical legacies and futurity. The fourth chapter returns to the Sars-CoV-2 pandemic, and more specifically to the debate surrounding face masks, by examining it through the lens of an ethics of breathing. The chapter further addresses the vulnerability of breath vis-à-vis the systemic use of suffocation and breathlessness as a means of control and hegemony. This is brought to bear on a reflection of the deaths by suffocation of Eric Garner and George Floyd. This chapter draws on the previous discussion on ethics to argue for the potential of resistance in breathlessness and for the right to breathe.

# 1. To Breathe

THE CRUMPLING OF A BROWN PAPER BAG that expands and deflates intersects the buzzing noise of the motorized bellows of an artificial respirator. They are linked by a transparent tube. The paper bag contains air, more specifically the collected breath of the late composer and accordionist Pauline Oliveros. As the breathed air moves between the paper bag and the artificial respirator, the transparent tube also emits a sibilant rasp. *Last Breath* (2012) by Mexican-Canadian artist Raphael Lozano-Hemmer simulates the respiratory frequency of a person inhaling and exhaling through the regular pulsation of this apparatus comprising a pump, a tube, and an inflatable paper bag.[1] The work captures the almost intangible material presence of the breath as air moves in and out of the brown paper bag and renders it overtly perceptible through the mechanics and sound of the apparatus itself. *Last Breath* alludes to the figurative significance of respiration as life and creativity. It suggests the unicity of an individual's breath, its inherent relation to oneself and to who we are, but also reminds us of the common-

1. Raphael Lozano-Hemmer, *Last Breath* (2012), multimedia installation and video, https://www.lozano-hemmer.com/last_breath.php. The installation is complemented by a video that shows Oliveros exhaling in the paper bag. Another breath captured is that of the Cuban singer Omara Portuondo. Lozano-Hemmer has intentionally selected artists whose creative practice involves breathing.

ality of breathing, of the fact that we all breathe. The paper bag is transposable, and another person's breath can be inserted into the physical apparatus of the installation, thus underlining the unicity and mutuality of breathing. Part biometric portrait, part commemoration, and part reflection on the impossibility of capturing presence, Lozano-Hemmer's *Last Breath* engages with breathing as an essential biological function and as a gaseous exchange that involves matter and movement, while also pointing to the ephemerality of the breath and its cultural and historical associations with life, individuality, inspiration, creativity, and spirituality. Indeed, matter and meaning, as Karen Barad argues, are not separate elements: "They are inextricably fused together" and constitute an entanglement "of substance and significance."[2] Breathing is one such entanglement.

Despite these interrelations, breathing has remained peripheral to thinking; while we don't normally think consciously about breathing, the breath continues to be marginal to critical discourses from philosophy to legal studies. Expanding on Luce Irigaray's comment on Martin Heidegger's philosophy as "one forgetting the breath," Lenart Škof and Petri Berndtson have turned to Eastern traditions of thought to postulate the potential of a "respiratory philosophy" that recognizes the ontological, epistemological, ethical, and political significance of the breath.[3] Škof and Berndtson propose a chiasmic relationship between breath and thought, whereby breathing and thinking are intertwined and influence each other reciprocally, producing what they refer to as "atmospheres of breathing."[4] Accordingly, their aim is to reorient "all the questions of philosophy as questions concerning the atmosphere of breathing."[5]

2. Karen Barad, *Meeting the Universe Halfway: Quantum Physics and the Entanglement of Matter and Meaning* (Durham N.C.: Duke University Press, 2007), 3.

3. Lenart Škof and Petri Berndston "Introduction," in *Atmospheres of Breathing*, ed. Lenart Škof and Petri Berndston, i–xxvii (Albany: State University of New York Press, 2018), ix–x.

4. Škof and Berndston, xi.

5. Škof and Berndston, xv.

These questions regard the historical formation of the oxygen in the atmosphere and the development of the organisms that use oxygen as the basis of respiration, positioning an understanding of breathing within a planetary ecology in which the earth itself participates in the elemental exchange of oxygen and carbon dioxide through forests, oceans, and mountains.[6] These questions can also be articulated around our individual ontological dependence on air and its implications for us who are immersed in air and whose lives rely on the continuous material exchange with our surrounding gaseous environment.[7] Tim Ingold also describes the enveloping presence of the atmosphere as both an admixture of bodies and a medium of interaction.[8] Air defines not only the metabolic exchanges enacted by respiration but also the conditions that enable movement and communication, "tempering" with its affect the atmospheres we inhabit.[9] For Ingold, the recognition of a common immersion in air, as matter and medium, means acknowledging that "the world we inhabit, far from having crystallised into fixed final forms, is a world of becoming, of fluxes and flows" or what he refers to as a "weather-world."[10] Pollution and other chemical contamination, however, put such connection with the atmosphere at risk. Ecological vulnerability further overlaps in the way in which air has become a means for the governance of bodies through authoritarian acts of suffocation. This entails an idea of air and breathing as "being politically and historically contextual,"[11] and in need of consideration within legal and

6. John Durham Peters, "The Media of Breathing," in *Atmospheres of Breathing,* ed. Škof and Berndston 179–95.

7. Petri Berndston, "The Possibility of a New Respiratory Ontology," in *Atmospheres of Breathing,* ed. Škof and Petri Berndston, 25–50.

8. Tim Ingold, "The Atmosphere," in *Chiasmi International,* 14 (2012): 75–87 at 77.

9. Ingold, 76–77.

10. Ingold, 80–81.

11. Marijn Nieuwenhuis, "Atmospheric Governance: Gassing as Law for the Protection and Killing of Life," *Environment and Planning D: Society and Space* 36, no. 1 (2018): 78–95 at 79. See also Marijn Nieuwenhuis, "Breathing Materiality: Aerial Violence at a Time of Atmospheric Politics,"

ethical discourses. Extending to air what María Puig de la Bellacasa argues for soil, we suggest that, because of its "ontological state" as essential to the life of human and other-than-human beings, air has to be rethought at the intersection of ecology and justice, critical frameworks and social theory.[12] Such rethinking, as Puig de la Bellacasa maintains, has important material, ethical, and affective implications in underpinning a politics of interdependence,[13] which also concerns air and breathing. Within such intersectionality and at the intertwining of substance and significance, of ontology and phenomenology, an ethics of breathing emerges as an attempt to critically engage with its vulnerability.

In this chapter, by positing breathing as entanglement, we consider its being embodied and its potential to affect and be affected. Accordingly, ethics itself is embodied and performative, and involves modes of being and acting. It entails attentiveness to the breath and how one breathes. Following Irigaray, a cultivation of breath also means communality, a recognition that we share the air we breathe and our responsibility for it. By drawing attention to the intersubjectivity of breathing, we shall further question its significance for breathlessness. Central to our discussion throughout is an understanding of breath as matter and meaning.

## To Breathe: An Entanglement

Life starts with the first gulp of air and ends when one ceases to breathe; breathing marks the interval between birth and death. Samuel Beckett's play *Breath* (1969) epitomizes the elemental

---

*Critical Studies on Terrorism* 9, no. 3 (2016): 499–521; https://doi.org/10.108 0/17539153.2016.1199420; Peter Sloterdijck, *Terror from the Air,* trans. Amy Patton and Steve Corcoran (Los Angeles: semiotext(e), 2009), 9–10.

    12. María Puig de la Bellacasa, *Matters of Care: Speculative Ethics in More Than Human Worlds* (Minneapolis: University of Minnesota Press, 2017), 1–17.

    13. Puig de la Bellacasa, 5.

state of breathing but also its tangled connections to meaning.[14] As Beckett himself commented:

> My contribution to the Tynan circus is a forty second piece entitled BREATH . . . It is simply light coming up and going down on a stage littered with miscellaneous unidentifiable muck, synchronised with the sound of breath, once in and out, the whole (ha!) begun and ended by the same tiny vagitus-rattle.[15]

Breath itself is a process composed of four different phases: inhalation, pause, exhalation, pause. Its rhythm, depth, and extension are variable depending on internal physical and psychological states and external environmental conditions. The changing pattern of the breath marks how we live, as it intersects feelings and emotions, thoughts and actions, seamlessly shifting from unconscious to conscious, from involuntary to controlled. To be in the world is to breathe, and life depends on the exchange between respiration and the gaseous environment that surrounds human and nonhuman living beings.

Physiologically, respiration designates the exchange of oxygen and carbon dioxide between an organism and the surrounding environment during inhalation and exhalation. This further enables the oxygenation of nutrients at the cellular level with the related production of energy and the elimination of waste. Breathing mostly happens automatically, adapting itself to an organism's inner and

14. Samuel Beckett, *Breath,* in *Krapp's Last Tape and Other Shorter Plays* (1969; London: Faber & Faber, 2009), 79. Artist Damien Hirst has realized a video installation based on Beckett's play, *Breath* (2001), in which the camera spans over a heap of medical debris and technical equipment, lingering over an ashtray and an empty bottle at the end, as we hear a long sighing exhalation.

15. Beckett wrote *Breath* for Kenneth Tynan's theater revue, *Oh! Calcutta!* He relates the short play to a citation by Ausone de Chancel. In his words, "I realized when too late to repent that it is not unconnected with *On entre, on crie / Et c'est la vie. / On crie, on sort, / Et c'est la mort,*" quoted in James Knowlson, *Damned to Fame: The Life of Samuel Beckett* (New York: Simon & Schuster, 1996), 565.

outer circumstances. At the same time, through the passage of air in and out of the body, the breath exposes the permeability of the body itself, its porosity and sensitivity to the surrounding environment. Through respiration air is alternatively taken into the body and expelled. This exchange and movement enable a flow of sensory information, including temperature, humidity, and smell, that can be perceived through the air that is inhaled. During exhalation, one surrenders carbon dioxide to the atmosphere but also other matter (including potential pathogens) and information—whether as the smell of our own breath or as sound. In fact, the exchange of air in and out of the body makes possible the articulation of sound and thus communication so that air and breath can be regarded as the conduits for thought and its expression.[16] Air is what enables us to move and communicate, it is also in itself a source of information and knowledge.[17] What does it then mean to breathe? What exchanges does the breath enact through air and figuratively beyond air?

Historically, in early Egyptian, Hindu, and Greek cultures, breathing was associated with the principle of life itself—what was regarded as life force or the soul. The Vedic myth of creation conceives all the elements as interconnected, whereby time ensues from the rhythm of breath, the world is created from sound, and form from the merging of air and touch.[18] According to the Yoga Sutras of Patanjali, *pranayama* is the practice related to the

16. Steven Connor, *The Matter of Air: Science and the Art of the Ethereal* (London: Reaktion Books, 2010); Peter Adey, *Air: Nature and Culture* (London: Reaktion Books, 2014); Gaston Bachelard, *Air and Dreams: An Essay on the Imagination of Movement*, trans. Edith R. Farrell and C. Frederick Farrell (1943; Dallas: The Dallas Institute Publications, 1988).

17. Tim Ingold, "Footprints through the Weather-World: Walking, Breathing, Knowing," *Journal of the Royal Anthropological Institute* 16, supplement (2010): S121–39.

18. Arthur H. Ewing, "The Hindu Conception of the Functions of Breath—A Study in Early Hindu Psycho-Physics," *Journal of the American Oriental Society* 22 (1901): 249–308.

breath, where *prana* means cosmic force; through a system of exercises meant to regulate, expand, and free the breath—the three meanings overlap—one relates intimately to this force and as a result to one's own oneness with the universe.[19] In ancient Greek philosophy, the term *pneuma* also referred to air in motion and, by extension, to the breath. The latter was understood as that which sustains consciousness in the body. Hence for Aristotle, *pneuma* is a dynamic principle, "the power (*dynamis*) of every kind of soul," which manifests as ether (the divine vital force and the quality of this force itself) within a living body and as such can be regarded as an "instrument of the soul."[20] For the Stoic philosopher Chrysippus, *pneuma* is the generative principle that regulates both the individual and the universe,[21] suggesting continuity through the breath between micro and macro forms of existence, physical and spiritual life. Maintaining such reciprocity, Hippocrates directly compares wind and breeze to breath, suggesting that "nothing is empty of air" and that air is in equal measure a cause of both life and disease, including what he refers to as "epidemic fever" that he relates to the sharing of the same air,[22] thus foregrounding an idea of vulnerability to air. Drawing from Hippocrates, the Roman physician Galen also recognizes breathing as an essential function of the human body and further distinguishes it as either automatic or controlled. According to an apocryphal account attributed to him, "slaves, lacking any other tool of protest, foiled their masters'

19. Patanjali, *The Yoga Sutras of Pantajali,* trans. and commentary Sri Swami Satchidananda (circa 300 A D; Buckingham, Va.: Integral Yoga Publications, 2013), book 2 verses 49–53, 148–53.

20. Abraham P. Bos, "'PNEUMA' As Quintessence of Aristotle's Philosophy," *Hermes* 141, no. 4 (2013): 417–34.

21. David Sedley, "Stoic Physics and Metaphysics," in *The Cambridge History of Hellenistic Philosophy,* ed. Keimpe Algra, Jonathan Barnes, Jaap Mansfield, Malcolm Schofield, 353–411 (Cambridge: Cambridge University Press, 1999), 388.

22. Katrin Klingan, Ashkam Sepahvand, Christoph Rosol, Bernd M. Scherer, eds., "Hippocrates—Breaths," in *Textures of the Anthropocene: Vapor* (Cambridge, Mass.: The MIT Press: 2014), 31–34.

plans by holding their breath until they died. Breathing was taken to be such a volitional thing that it gave any breather ultimate determination over their own life or death."[23] The emphasis on volition tightly links breathing to cognition and autonomy; it refers to the possibility of choice and of self-determination, thus rendering the breath a site of resistance in ways that resonate with contemporary utterances where breath or its suppression is invoked as protest against injustice, while freedom of breathing coincides with claims of civic and political liberties.

In antiquity, however, breathing was not related to the lungs and what we now regard as the respiratory system; it was believed to have mainly a cooling function through the pores of the skin.[24] Only with advances in the understanding of animal and human anatomy and the beginnings of physiology did the role of the lungs in respiration begin to be explained. This coincided with the first pneumatic experiments in the late sixteenth century and the discovery of oxygen in 1774.[25] Antoine Laurent de Lavoisier postulated that air was composed of oxygen and nitrogen, and was the first to measure the exchange of oxygen and carbon dioxide during respiration both at rest and during an activity, thus demonstrating the physiological purpose of respiration was that of a gaseous exchange.[26] Charles Darwin, in his study *The Expression of the Emotions in Man and Animals* (1872), regarded breathing as a reflex movement that is altered under stress, partaking of the physical articulation of emotional states.[27] This is, however, an involuntary response inscribed

23. Alice Malpass et al., "Disrupted Breath, Songlines of Breathlessness: An Interdisciplinary Response," *British Medical Journal—Med Humanities* 45 (2019): 294–303 at 298.

24. Jean-William Fitting, "From Breathing to Respiration," *Respiration: International Review of Thoracic Diseases* 89, no. 1 (2014): 82–87 at 83.

25. Fitting, 85–86.

26. Fitting, 86.

27. Charles Darwin, *The Expression of the Human Emotions in Man and Animals*, with an Introduction, Afterword, and Commentary by Paul Elkman (1872; London: Harper Collins Publishers, 1999), 41–42.

within a mechanistic model of the body. To consider breathing uniquely as a reflex undermines the role that volition can play in regulating breathing patterns, and more conspicuously divorces the breath from the web of associations that made it the permeable mediator between inner and outer life, between the individual and the surrounding environment.

Current approaches to respiration have reevaluated its interrelation with psychological and mental states as well as with physiological processes. Traditional Chinese medicine, for instance, already associated the breath with emotions and regarded its vigor as essential to well-being.[28] Accordingly, any irregularities in breathing were believed to be signs of illness and psychological suffering, a correlation that has gained relevance in the current understanding of breathing,[29] thus underlining the complex mediating role of respiration within the body and in its surrounding environment. The regular rhythm of the breath, which mostly remains below the conscious perceptive threshold, punctuates the position of the body in space as the breath constantly adjusts to the external climatological and physical conditions of the atmosphere.[30] Coughing, gasping, shortness of breath, or hyperventilation can be due to physiological conditions and respiratory problems or may be responses to external factors, such as temperature or the presence of irritants in the air, like pollens or dust. Breathing irregularities, however, can also be related to emotional states: fear and anxiety

28. For a discussion of Qi in Chinese philosophy, see Jana S. Rošker, "The Concept of *Qi* in Chinese Philosophy: A Vital Force of Cosmic and Human Breath," in *Atmospheres of Breathing*, ed. Škof and Berndtson, 127–40.

29. Reinhild Draegher-Muenke and Maximillian Muenke, "The Healing Energy of Breath in Traditional Chinese Medicine," in *Functional Respiratory Disorders*, ed. Ran D. Anbar, 301–23 (Totowa, N.J.: Brand Humana Press, 2012).

30. Havi Carel, "Invisible Suffering: The Experience of Breathlessness," in *Atmospheres of Breathing*, ed. Škof and Berndtson, 233–45 at 233–34.

can cause feelings of suffocation, making one gasp for air, while anger and rage tend to induce hyperventilation.

It is within such diverse interpretations that the gaseous transmutation and interchange made possible by respiration can be thought of as actualizing the inherent relationship of organisms, including the human body, with their living surroundings, establishing intraconnectivity among them locally and, since air constantly moves, more expansively elsewhere. This involves the perception of the continuous flux of matter in the air, be it pollutants or information. Even minute changes in the breath are affective events that modify and actualize the individual interaction of a body both physically and emotionally with its surrounding environment, typifying its dependency on an air-bound state and its interdependence with all other human and nonhuman entities in that environment.

## To Breathe: Toward an Embodied Ethics

According to Irigaray, this dependency on an air-bound state is fundamental to being and to being in the world: to breathe designates both individuality and commonality. Breathing is both an action and an exchange, since it "corresponds to the first autonomous gesture of the living human being. To come into the world supposes inhaling and exhaling by oneself."[31] Air is a source of life and, for Irigaray, we are because we breathe.[32] To be embodied and to breathe is prior to thought and thought itself manifests through the embodied action of breathing. If the dependence of life on air suggests an ontological condition of being in the world through the

31.  Luce Irigaray "The Age of Breath," in *Luce Irigaray: Key Writings,* 165–70 (London: Continuum, 2004), 165.

32.  Luce Irigaray, "From *The Forgetting of Air* to *To Be Two,*" trans. Heidi Bostic and Stephen Pluáček, in *Feminist Interpretations of Martin Heidegger,* ed. Nancy J. Holland and Patricia Huntington, 309–15 (University Park: Pennsylvania State University Press, 2001), 310. See also Luce Irigaray, *The Forgetting of Air in Martin Heidegger,* trans. Mary Beth Mader (London: The Athlone Press, 1999).

breath, a phenomenology of breathing—as an embodied process and autonomous action that implicates movement, transformation, and exchange—also involves a relational positioning of the self with one's surrounding through the inhalation and exhalation of air. Irigaray's shift from *cogito* to breath, from the abstract to the embodied, thus suggests a new focus on the flow of air within the body, with its palpable, physical rhythm, constant interchange, and attunement to movement—on what, drawing on ancient theories, can be regarded as the principle of life itself. The autonomous action of breathing, however, also needs attention. Drawing on Eastern philosophies and their emphasis on the breath as key to meditative practices, Irigaray underlines how an awareness of breathing acquires an ethical dimension as it is "a vehicle both of proximity and of distancing," a site of presence but also of disappearance, since breathing is both an individual action that determines one's own singularity and a sharing with all those (human and nonhuman) that inhabit the surrounding world.[33] Breathing is thus an action of mediation between the individual and the surrounding, the self and the other, as it simultaneously encompasses both singularity and plurality. "I can"—in Irigaray's words—"breathe in my own way, but the air will never be simply mine. To breathe combines in an indissociable way being-there and being-with."[34] This fundamental association of "being-there" and "being-with" through the breath and the sharing of air refers to both physical and figurative interactions within and without, individually and collectively. An

33. Irigaray, "From *The Forgetting of Air* to *To Be Two*," 311–12.
34. Irigaray, 312. See also Luce Irigaray, "To Begin with Breathing Anew," in *Breathing with Luce Irigaray*, ed. Lenart Škof and Emily A. Holmes, 217–26 (London: Bloomsbury, 2013); and Lenart Škof and Emily A. Holmes, "Towards Breathing with Luce Irigaray," in *Breathing with Luce Irigaray*, ed. Škof and Holmes, 1–14; Lenart Škof, *Breath of Proximity: Intersubjectivity, Ethics, and Peace—Sophia Studies in Cross Cultural Philosophy of Traditions and Cultures* (Dordrecht: Springer, 2015); Magdalena Górska, *Breathing Matters: Feminist Intersectional Politics of Vulnerability* (Linköping: Linköping University, 2016).

ethics of breathing thus pertains to the body and to being embodied, as both interactions and *intra-actions*. It presupposes an intimate and individual experience of oneself and one's permeability to the external flux of sensations, as well as a sense of "disappearance," or deindividualization, through the incorporation of air itself. By breathing, we experience both autonomy and commonality as we unconsciously perceive not only our own breathing patterns but also those close to us.[35]

Such an ethics finds expression as an embodied and tangible experience in *Breath Catalogue* (2014–18), a collaboration between dancers/choreographers Kate Elswit and Megan Nicely with data scientist Ben Gimpert and composer Daniel Thomas Davis. *Breath Catalogue* comprises a series of what the artists refer to as "curiosities," drawing the term from the collections of natural and cultural specimens of seventeenth-century cabinets of curiosities. In the case of *Breath Catalogue,* such curiosities are a collection of performed actions that explore the interrelation of breath and movement through manipulation and disruption.[36] "Breath," as Elswit explains, "is fundamental to us as dancers and people, and yet itself is curious—assumed and automatic but unpredictable in the ways it shifts through so many dimensions of lived experience and slips between conscious and unconscious realms."[37] *Breath Catalogue* expands on the use of breath patterns by contemporary dancers for timing and coordinating movements; breathing enables them to synchronize and confer intentionality on their movements, anchoring them in an awareness of the body and its

35. See Carel, "Invisible Suffering," 236–40. Carel examines the isolation felt by patients suffering from pathological breathlessness from a phenomenological perspective.

36. Kate Elswit, Megan Nicely, Ben Gimpert, *Breath Catalogue* (2015–18), https://www.breathcatalogue.org/. See also Kate Elswit, "A Living Cabinet of Breath Curiosities: Somatics, Bio-media, and the Archive," *International Journal of Performance and Art Media* 15, no. 3 (2019): 340–59. I am indebted to Elswit's article for my reading of this work.

37. Elswit, "A Living Cabinet of Breath Curiosities," 340.

modulation of the spatio-temporal continuity defined by tempo, directionality, sequence or repetition. The performers and Gimpert use experimental dance techniques together with technologies for collecting and visualizing biodata—such as wearable sensors and audio recording—in order "to make the performers' breath palpable to an audience, engaging with performance as a laboratory in which to explore new means of cataloguing and circulating multidimensional sensory experiences, between measurement and memory."[38] Premiered in San Francisco in 2015, *Breath Catalogue* evolved over a period of three years by delving into such experimentation of the physical connection between breath and movement and its inherent integration with emotional states. This is the case, for instance, in the way in which Elswit and Nicely use "flocking," an improvisation technique in "which dancers shadow one another's movements" in changes of direction and leading: the sharing of breath patterns, as Elswit explains, allows them "to increase accuracy in positioning and particularly timing of unison movement through a synchronization of the breath as a means for synchronizing bodily movements developed in previous improvisations."[39] This could involve exaggerated inhalation augmented by the arching of the torso or sharp exhalation combined with arm movements. While the performers, as in this example, engage with "the ways in which bodies themselves already archive and retrieve the sensory information of breath experiences,"[40] many of the "curiosities" that were developed in the project also responded to and kinetically engaged with data collected through biofeedback that was presented through visualizations. In the case of "flocking," the visualization used Nicely's live breathing data and showed particles being condensed during the inhalation and then scattered as if blown out through exhalation. In another example, "Settling Trio," the feedback loop, as Elswit explains, was more intricate:

38. Elswit, 340.
39. Elswit, 351.
40. Elswit, 350.

Nicely, wearing a sensor, sets up a settling game, in which she moves for the length of a long exhalation, then suspends movement and breath to wait for the visualization to settle before exhaling another sequence of movement. After she establishes this pattern, I [Elswit] enter at the end farthest from the projection and Nicely turns to face me. The rest of the curio extends the duet into a trio: Nicely trails my movement, which is directed by a score based on me watching the visualization of her breath animate and settle, as she watches and follows my movement that plays the game now with her breath, producing, in turn, further chains of movement. The settling game already introduces a time-shift, and the refraction through an additional breathing body extends that cycle further.[41]

The use of visualization has critical relevance as a means of "recomposing the living breath investigation in a manner that shares rather than shows."[42] *Breath Catalogue,* in other words, offers a performative approach that aims to make palpable for the audience the breath patterns of the dancers and their affect. Indeed, as Elswit argues, "to think about the sensible qualities of breath engaged as archive before an audience requires first dealing with breath as already a medium that tangles with palpability, moving between bodies at the same time as it challenges the limits of perceptibility."[43] By assuming the possibility of archiving the breath and creating a perceptible catalogue of performed patterns, Elswit does not presume that the palpability of the breath is in itself communicative but rather that it can become so by drawing the audience's attention to its physicality as breath and movement are disarticulated and recomposed in performance. The audience is, using Irigaray's words, asked "to attend to the breath" and be perceptive if not attuned to its physical qualities and potential meanings in the performance. In *Breath Catalogue,* the association argued by Irigaray of "being-there" and "being-with" enacted by the breath is brought to bear in the forms and patterns that such embodied presence and communality entail.

41.  Elswit, 352.
42.  Elswit, 351.
43.  Elswit, 344.

Neither is a stable condition but rather a modifying relation that, not unlike the breath itself, adapts its pulse and depth to the shifts and changes of the internal and external environments, to their affective, cognitive, and emotional information. Breathing thus both entangles us with otherness and generates its own volatile atmosphere of connections, responses, and articulations.

## To Breathe, Once More

The continuity and reciprocity that respiration generates with one's surrounding, as *Breath Catalogue* suggests, also involves an entanglement of palpability and perceptibility, of affect and communication. Such reciprocity can however be disrupted when breathing becomes difficult and one struggles for air. *The Life of Breath*—an interdisciplinary project that addressed the interrelation of breathing and breathlessness in terms of illness and wellbeing[44]—focused on the embodied experience of breathlessness and its affect by bridging medical history and anthropology, philosophy, literature, and public policy. The project examined the complexity of breathlessness, incorporating emotion, association, and the existential dimensions that are part of the experience of breathing and breathlessness into an understanding of the very experience of breathlessness, especially as a pathological condition, exposing the differences and nuances denoting it.[45] Hence, for instance, the analyses of the responses given by a man suffering from respiratory chronic obstructive pulmonary disease demonstrate that breathing difficulties emphasize the complex interrelation of the different qualities that breathing can take—ranging from at rest (smooth) to under exertion (rattled, gasping, painful)—with psychosomatic perceptions and articulations of the self that breathing encapsulates.

44. Malpass et al., "Disrupted Breath," 294. Elswit also refers to this project in her article, see Elswit, 345–47.
45. Carel, "Invisible Suffering," 234–35.

Chronic respiratory problems raise the question for the individual of who is breathing. As Havi Carel observes,

> In pathological breathlessness, blood oxygen levels can drop severely, leading to dizziness, fainting, shaking, excessive sweating, and a sense of doom. It is a total and overwhelming experience of loss of control and is acutely unpleasant. It removes the breathless person from the normal course of events and can cause deep anxiety, panic attack, and trauma.[46]

Breathlessness generates a fractured perception of the integration of body and self that further upsets the interrelationship of matter and meaning that the inhalation and exhalation of air epitomize ontologically. The sufferer feels "trapped" in the uncertainty and fear that breathlessness causes, shrinking one's experience and imbuing every action with foreboding.[47] However, insufficient diagnostic tools and the difficulty of explaining breathlessness render chronic respiratory conditions and those who suffer from them "invisible" in medical contexts and beyond.[48] This book argues that such invisibility, and the disturbance of the affective and emotional connectivity established by the breath within the individual and intersubjectively, extends beyond respiratory disorders to encompass other forms of breathlessness where ecologies, politics, and violence put breathing at risk. Issues of visibility are thus key to a critical questioning of breathing. Elswit demonstrates the circulation of breath across bodies as affect, further engaging with alternations of breathing patterns to mobilize and performatively articulate the perceptive qualities and emotional resonances that accompany the disturbance and interruption of respiration, alerting us that breathlessness engenders its own affect and emotional charge, its own motion and stillness. Breathlessness thus also moves bodies. An attention to the motions and pauses of breath, to its gasps and gaps,

46. Carel, 237.
47. Carel, 237–38.
48. Malpass et al., "Disrupted Breath," 297. See also Carel, "Invisible Suffering," 238–40.

is key to an ethical understanding of breathing and to the necessity of making breathlessness visible in order to unpack its significance and resonances. Intersubjectivity encompasses the other and by extension the relations, exchanges, and actions that bring one into contact with others, environments, and the air itself. It is a position from which to critique spatial and temporal boundaries by acknowledging the autonomy but also the intrarelational agency (between oneself and others) that underpins and comes with breathing.

This chapter started with the image of the inflating and deflating of a paper bag connected to a bellows by a transparent tube through which air moved. I'd like to conclude with another image: a series of seven discs hanging at eye level that reflect the mirror image of the viewer. When breathed upon, however, another face emerges from the thin layer of condensation, a small photographic portrait of someone else. That other image lingers for a brief moment before disappearing. *Breath* (1996–2000) by Columbian artist Óscar Muñoz[49] reminds us of the fleeting presence of a breath and its association with the transience of life, but also of the exchange and communality it enacts at the threshold of visibility, in the vaporous space where each breath rests and evaporates. The faces that briefly appear on the discs in the midst of a breath are those of people killed in Columbia by political violence. Muñoz collected the photographic portraits from newspaper obituaries, directly alluding to the violence that mars Columbian society through a "fading illustration of human loss" that transforms "the images of war victims into self-reflections."[50] In *Breath,* Muñoz gives presence to those made invisible by an authoritarian regime through the unpalpable substance of one's breath. According to ancient Mesoamerican belief systems, the breath or wind mediated between the spirit of the

49. Óscar Muñoz, *Breath* (1996–2000), silkscreen on metal mirrors, https://moisdelaphoto.com/en/artistes/oscar-munoz/.

50. Caroline Menezes, "Óscar Muñoz: The Presence of the Absence" (2008), https://www.studiointernational.com/index.php/oscar-munoz-the-presence-of-the-absence.

living and their ancestors—what was thought to be animate and inanimate matter. Muñoz's *Breath* resonates with such continuity through the encounters that a breath can reveal.

As I am writing, we are in the midst of the second wave of Sars-CoV-2. Infection rates worldwide are rising and the UK has entered its second national lockdown. Muñoz's figurative encounter can be imaginatively transposed to the current situation as we envision our self-reflection overlapping with the features of those who have died from the Sars-CoV-2 viral infection, those who struggle with breathlessness caused by it but also with other forms of suffocation. Such encounters inform what follows as an attempt to engage with the evanescence of air and to stay with the images, forms, and movements that breathing or breathlessness reveal so as to experience their affect and contend with the questions they raise. In this sense we shall attend to the breath as embodied experience, knowledge, and action.

## 2. Ecologies of Breathing

IN 2004, San Francisco-based environmental artist Amy Balkin launched the project *Public Smog*, a "park in the atmosphere that fluctuates in location and scale."[1] A range of legal, financial, or political activities determine the location, area, and duration of the park. These include the purchase of "emission offsets in regulated emissions markets, making them inaccessible to polluting industries."[2] Another activity of *Public Smog* is "the attempt to nominate Earth's atmosphere for inscription on the UNESCO's World Heritage List" by way of having signatory states of the World Heritage Convention present a nomination file.[3] *Public Smog* belongs to artistic practices that creatively engage with the ecology of air and whose lineage dates back to the art activism of the 1970s, such as Ant Farm's *Clean Air Pod*—an installation created at the University of California, Berkeley, on the occasion of the first Earth Day in 1970. While Ant Farm's *Clean Air Pod* indicated the growing preoccupation with air pollution by offering a self-contained bubble of uncontaminated air as a utopian space in the midst of Berkeley's urban environment,

1. Amy Balkin, *Public Smog* (2004), http://tomorrowmorning.net/publicsmog.
2. Balkin, *Public Smog.*
3. Balkin, *Public Smog.* See also T. J. Demos, *Decolonising Nature: Contemporary Art and the Politics of Ecology* (Berlin: Sternberg Press, 2016), 106–12.

Balkin calls for public action to protect the atmosphere as a shared heritage by directly addressing the interference of politics and economics in the safety of air. As a legacy always implies the continuation of the past into the present and a potential future, viewing the atmosphere as a heritage, a vaporous and yet highly tangible legacy, confronts us with questions of what we have inherited and what is our responsibility in maintaining it, who is accountable for the preservation of air, and what histories saturate the atmosphere itself. The difference between Ant Farm's attempt to raise awareness about air pollution in the 1970s and Balkin's *Public Smog* project in the early 2000s is, in fact, not so much a shift in emphasis from ecology to ethics but rather a tightening of the knot between them, as an ever more complex intertwining vis-à-vis air toxicity.

Toxic air raises issues of visibility. Through a consideration of artworks that engage with the ecology of air, we shall address in this chapter the intertwining of ecology and ethics and further examine how breathlessness epitomizes the systemic violation of air that characterizes contemporary environments. This resonates with the call for "the universal right to breathe" that the SARS-CoV-2 pandemic has brought to the fore. The breath's entanglement of matter and meaning argued in the previous chapter is here further inflected in terms of the forms of knowledge and doing that encompass being as breathing.

## To Make Air Visible

Preoccupations with the quality of air and its effects on wellbeing have a long history; foul air was believed to be a cause of ill health and a carrier of contagion from antiquity to the late eighteenth century. Since the mid-nineteenth century, however, our relationship with air has been increasingly endangered by manmade pollution. In Britain, for instance, sanitary and public health acts were first promulgated in the 1860s and continued well into the first decades of the twentieth century in an attempt to control industrial emissions. These were followed in 1956 by the Clean

Air Act that introduced smoke-control areas and prohibited the emission of dark smoke from chimneys; this was further revised in 1968, till the promulgation of the European Community directive against pollution became effective in 1971.[4] Since 2008, legislation in the European Community around clean air has been increasingly merged into single directives and the implementation of policies for the exchange of information and data on air quality.[5] Despite these attempts to temper air pollution, its level has increased exponentially around the world and is regarded today as a major health threat, with an estimated 8.7 million deaths a year from exposure to air pollutants.[6] However, as Rebecca Solnit argues, not only is the estimated number critical, but "how invisible those deaths are, how accepted, how unquestioned."[7] Air monitoring includes the measurement of gases (sulphur dioxide, carbon monoxide, nitrogen dioxide, and ozone) and of polluting particles (from 10 microns to

4. http://www.air-quality.org.uk/02.php. For the history of legislation on air pollution in the United Kingdom, see Mark Whitehead, *State, Science, and the Skies: Governmentalities of the British Atmosphere* (Oxford: Wiley-Blackwell, 2009).

5. See Directive 2008/50/EU, and Directive 2011/850/EU, https://ec.europa.eu/environment/air/quality/existing_leg.htm. For further European Union regulations on Eon air pollution see https://www.loc.gov/law/help/air-pollution/eu.php. In the United States emission regulations followed a similar though slightly delayed trajectory. For a discussion of the Clean Air Act in the United States, see Beth Gardiner, *Choked: The Age of Air Pollution and the Fight for a Cleaner Air* (London: Granta, 2019), 145–68. See also Paulo Tavares, "Stratoshield," in *Textures of the Anthropocene: Vapor,* ed. Katrin Klingan, Ashkan Sepahvand, Christoph Rosol, and Bernd M. Scherer, 61–71 (Cambridge, Mass.: MIT Press, 2014), 68–71.

6. Oliver Milman, "'Invisible Killer': Fossil Fuels Caused 8.7m Deaths Globally in 2018, Research Finds," *The Guardian,* February 9, 2021, https://www.theguardian.com/environment/2021/feb/09/fossil-fuels-pollution-deaths-research. See also World Health Organization, Health Topics: "Air Pollution," https://www.who.int/health-topics/air-pollution#tab=tab_1.

7. Rebecca Solnit, "There's Another Pandemic under Our Noses, and It Kills 8.7m People a Year," *The Guardian,* April 2, 2021, https://www.theguardian.com/commentisfree/2021/apr/02/coronavirus-pandemic-climate-crisis-air-pollution.

less than 2.5 microns in diameter). Fine particles are especially dangerous to health because, once inhaled, micropollutants, both for their size and chemical composition, trigger widespread inflammatory processes whose long-term effects are damaging to all organs in the body.[8] According to a review in February 2019 by the Environmental Committee of the Forum of International Respiratory Societies, vulnerability to air pollution is "made worse by health inequality and environmental injustice"[9] that have increased through social factors such as poor housing and diet that render certain groups more vulnerable than others: "Although air pollution affects people of all regions, ages, and social and economic groups,"[10] individuals on low income and ethnic minorities living in segregated areas are more likely to be exposed to high levels of pollution. The same can be said for people living in regions of the Middle East, India, Asia, and Africa—where environmental issues intersect long-lasting conflicts. The authors of the review conclude,

> Reducing vulnerability across a population calls for reducing poverty, segregation, and health-damaging neighbourhood environmental factors as well as reducing the ambient level of pollutants. Strategies to achieve health equality for vulnerable communities requires societal commitment of resources as well as the promulgation of air quality control measures.[11]

This vulnerability accords with what Franco Bifo Berardi refers to as a pervading state of physical and psychological breathlessness where pollution and also unequal distribution of resources and fear of violence converge, implicating air toxicity with economics and politics.[12] These entanglements are inscribed within

8. Dean E. Schaufragel et al., "Air Pollution and Noncommunicable Diseases: A Review by the Forum of International Respiratory Societies Environmental Committee, Part 1: The Damaging Effects of Air Pollution," *CHEST* 155, no. 2 (2019): 409–16 at 411.

9. Schaufragel et al., 415.

10. Schaufragel et al., 414.

11. Schaufragel et al., 415.

12. Franco (Bifo) Berardi, *Breathing: Chaos and Poetry* (South Pasadena, Calif.: semiotext(e), 2018), 52. See also Beth Gardiner, "White

"a historical-political terrain formed both by environmental forces and by social cleavages, local ecologies and global vectors of power and capital, and, crucially, by the frictions and relations established among them."[13] Clearly, power and social and racial inequalities affect the distribution of ecological factors, calling into question issues of visibility and agency concerning air pollutants and responses to risks. "In this sense," Paulo Tavares remarks, "situations of 'environmental-social emergency' [ . . . ] are always, at least potentially, intrinsically political, insofar as the coagulation of these diffused forces may threaten established regimes of power inasmuch as they put the life of marginalized populations on the edges of survival."[14]

Such issues, in their specific local manifestations, are at the core of diverse projects by artists, architects, and designers aimed at raising public awareness about air pollution. These include *Dust Plan* (2015) by Chinese performance artist Brother Nut, who addressed Beijing's polluted air over a period of three months by hoovering up air-polluting particles from the city's streets with an industrial vacuum clear and making a brick from the dust. In *Nuage Verte* (2008), the artist duo Hehe (Helen Evans and Heiko Hansen) used a green laser beam to illuminate the emissions cloud released by a power plant in Helsinki;[15] one could see the size of the cloud changing in relation to the energy consumption of local residents. In *Domestic Catastrophe Nº3: La Planète Laboratoire* (2012),[16] the same artists conveyed the unstable circulation and flux of air pollution,

---

Supremacy Goes Green: Why Is the Far Right Suddenly Paying Attention to Climate Change?" *New York Times*, February 28, 2020, https://www.nytimes.com/2020/02/28/opinion/sunday/far-right-climate-change.html.

13. Tavares, "Stratoshield," 67.

14. Tavares, 67–68.

15. Hehe, *Nuage vert (Green Cloud)* (2008), http://hehe.org.free.fr/hehe/texte/nv/.

16. Hehe, *Domestic Catastrophe Nº3: La Planète Laboratoire (Domestic Catastrophe Nº3: The Laboratory Planet)* (2012), http://hehe.org.free.fr/hehe/planet/index.html.

whose boundaries, location, and intensity are susceptible to con-
stant change and movement, by creating a model globe spinning on
its axis in a small water tank, while a light pointing to the Northern
Hemisphere irradiates fluorescent green gas that slowly expands
around the spinning globe to the sound of operatic music. Hehe's
floating globe is an eerie evocation of the constant fusion and mo-
tion of emissions in the atmosphere, whose surreal beauty disguis-
es the systemic contamination that affects our air-bound state. In
bringing to bear aesthetics on air toxicity, these diverse artworks
make visible our vulnerability to the hidden nature of air pollution.
Visibility here does not refer uniquely to representation but to an
embodied sensory recognition of a situation that is mostly accepted
despite its long-term effects. Hence, these artistic practices do not
present pollution as an event but rather as an ongoing process of
intra-actions among different systems and environments bringing
to the fore our shared responsibility through our daily actions and
their implications.

In rendering pollution visible, these artists further present us
with the ever-changing situation of air resulting from such variables
and intervening factors as the impact of emissions on the ozone level
and of social and economic conditions. Indeed, as architect Nerea
Calvillo, whose long-standing project *In the Air* (2008–ongoing)[17]
examines air conditions in relation to the urban fabric, demograph-
ics, and transportation networks in cities as diverse as Madrid,
Budapest, and Santiago, comments, "Making the levels of air pol-
lution visible allows us to measure the inequalities of a city and to
understand the complexities of the urban fabric and the shifting
demographic. It enables us to understand our own cities different-
ly, and to have a more critical understanding of the space we live
in."[18] Such an understanding is central to challenging the unequal

17.  Nerea Calvillo, *In the Air* (2008–ongoing), http://www.intheair.es/.
18.  Nerea Calvillo in conversation with Rose Thompson, in *Eco-
Visionaries,* exhibition catalogue (London: The Royal Academy of Arts,
2019), 84–92 at 92.

distribution of safe breathing caused by poor air quality but also to making tangible the inescapable entanglement between physicality and meaning that is manifest through its effects, whether as respiratory diseases or temporary feelings of choking and gasping for cleaner air. Artist Michael Pinsky, in collaboration with Cape Farewell Project (Climart), the Norwegian Institute of Air Research and AirLabs, has developed an immersive installation, *Pollution Pods* (2017), consisting of five geodesic domes that reproduce the air conditions in five different locations across the globe: Trautra in Norway, London, San Paolo, Delhi, and Beijing.[19] The distinct quality of the air in each pod is perceptible as smell, level of toxicity, temperature, and humidity. The installation translates different living environments into a felt experience in which, through breathing, the visitor can grasp how air vulnerability affects people in affluent as well as less affluent parts of the world. In so doing, Pinsky's installation points to the higher vulnerability of air toxicity in places like Delhi and San Paolo, where air pollution is also the result of histories of economic exploitation and marginalization that have marred their communities and ecosystems alike. Conflagrations and deforestation are concurrent causes of pollution together with the extraction and deployment of energy-producing fossil fuels, while bomb detonation and chemical warfare also emit noxious traces of contaminating fumes. Inherent in these overlapping forms of abuse and destruction of the atmosphere is fear itself as another matter that subverts the inherent relation of breath to life.

## To Breathe: A Principle of Action

Forensic Architecture is a multidisciplinary research agency, including architects, artists, filmmakers, lawyers, software developers, and journalists based at Goldsmiths, University of London,

19. Michael Pinsky, *Pollution Pods* (2017), http://www.michaelpinsky.com/project/pollution-pods/.

that supports human rights groups and other agencies by using architectural methodologies to investigate ecological and human rights violations.[20] In their video *Cloud Studies* (2020), Forensic Architecture navigates the collusion of political and economic powers, of ecology and human rights by presenting eight investigations that encompass airstrikes, the use of white phosphorous and the aerial spraying of herbicides in the Gaza Strip, the military use of chlorine gas in Syria, forest fires in Indonesia, methane spillage in an oil fracking facility in Argentina, and the deployment of tear gas to disperse demonstrations worldwide.[21] While I shall discuss this work and some of the investigations it comprises in more detail in the following chapter, it is worth pointing out the deeper implications of air toxicity by drawing on Forensic Architecture's study of lethal clouds and the critical understanding it offers.

"Mobilized by state and corporate powers"—remarks the voiceover in *Cloud Studies*—"toxic clouds colonize the air we breathe across different scales and durations, from urban squares to continents and from incidences to epochal latencies."[22] Evanescent and unstable clouds form, move, change, and dissipate in the atmosphere leaving polluting traces. Only the data extrapolated from such traces substantiate their lingering presence in the atmosphere, "shifting the relationship between data points from linear to relational."[23] This is the case, for instance, in the deforestation by fire in Kalimantan, Indonesia, in 2015 that released a large cloud of carbon monoxide that drifted north and westward affecting other areas in Indonesia, Malaysia, and Singapore, before reaching the northern parts of Thailand and Vietnam, causing an estimate of more than

20. Eyal Weizman, *Forensic Architecture: Violence at the Threshold of Detectability* (New York: Zone Books, 2017), 9.
21. Forensic Architecture, *Cloud Studies* (2020), video, https://forensic-architecture.org/investigation/cloudstudies.
22. Forensic Architecture, *Cloud Studies,* voiceover.
23. Eleanor Zeichner, "The Examined Sky," in Forensic Architecture, *Cloud Studies: Responses to the Cloud* (2020), 1–3 at 1, https://art.uts.edu.au/wp-content/uploads/CloudStudies-Book-Final-Web.pdf.

one hundred thousand premature deaths.[24] *Cloud Studies* juxta-
poses the visualization of the cloud's drift with that of other toxic
emissions caused by chemical weapons and tear gas in places as
diverse as Argentina, Egypt, and Hong Kong, associatively inflecting
what can be regarded as "a cross-border condition of suffocation."[25]
Not unlike Christina Sharpe's notion of the weather in the wake
of slavery as total environments imbued with racial prejudice and
violence,[26] the atmosphere becomes the foreboding sign of lethal
climates of abuse. Clouds are thus the referent for the "porousness
of global borders and the corruptibility of air."[27] *Cloud Studies* acts
as a contemporary atlas translating the historical painterly attempt
to capture the transience of clouds into digital maps of toxicity that
visualize the "non-linear and multi-causal logic"[28] governing the
lingering and drifting of lethal air particles. Such a logic of causation
is difficult to document, and the work of Forensic Architecture is
characterized by both persistence and resistance in its attempt to
move across different scales of cloud formation and toxic latency.
Indeed, "today's toxic fog breeds lethal doubt, and clouds shift once
more from the physical to the epistemological. When naysayers
operate across the spectrum to deny the facts of climate change just
as they do of chemical strikes, those inhabiting the clouds must find
new ways of resistance."[29] Resistance—as Sharpe argues in relation
to racial violence, and we shall return to her argument in the last
chapter—involves the breath as *aspiration*, as a forceful inhalation
that creatively counteracts suffocation.[30]

Following Jacques Rancière, an ethics of breathing emerges with-
in this context as a principle of action. Rancière traces the etymology

24. Forensic Architecture, *Cloud Studies*, voiceover.
25. Forensic Architecture, *Cloud Studies*, voiceover.
26. Christina Sharpe, *In the Wake: On Blackness and Being* (Durham,
N.C.: Duke University Press, 2016), 104.
27. Zeichner, "The Examined Sky," 1.
28. Forensic Architecture, *Cloud Studies*, voiceover.
29. Forensic Architecture, *Cloud Studies*, voiceover.
30. Sharpe, *In the Wake*, 113.

of ethics to the ancient Greek word *ethos,* which, before referring to a norm, signified both "the dwelling and the way of being, or life-style, that corresponds to this dwelling. Ethics, then," he continues, "is the kind of thinking in which an identity is established between an environment, a way of being and a principle of action."[31] If our way of being is through breathing in physical and other terms, as Irigaray suggests, vulnerability to toxic air undermines this corre-spondence between dwelling and a way of being by interfering with the very association between breathing and life, disrupting the phys-ical and figurative rhythm that the breath establishes individually and collectively by threatening the cadence of life itself. Such inse-curity toward the gaseous environment that supports life generates fears and anxieties that instead upset an ontological state of being. To use Rancière's term,[32] the *indistinction*—the blurring of bound-aries between life enhancement and risk, safety and fear—mobilizes ethics as a principle of action vis-à-vis vulnerability to air toxicity by engaging with the contingency and meaning that breathing ac-tivates both individually and collectively within environments that are affected by endemic histories of war, migration, marginalization and deprivation as much as by chemical pollutants. In this sense, as Jane Bennett suggests, "ethical responsibility resides in one's response to the assemblages in which one finds oneself participat-ing,"[33] corroborating the centrality of ethical responsibility in the intra-actions of knowing, being, and doing. Matter itself, according to Michel Serres, has become "gaseous," "more airlike than liquid, more informational than material. The global is fleeing towards the fragile, the weightless, the living, the breathing."[34] In this shift

31.  Jacques Rancière, "The Ethical Turn in Aesthetics and Politics," in *Aesthetics and Its Discontents,* trans. Steven Corcoran, 109–32 (Cambridge: Polity Press, 2009), 110.

32.  Rancière, 116.

33.  Jane Bennett, *Vibrant Matter: A Political Ecology of Things* (Durham N.C.: Duke University Press, 2010), 37.

34.  Michel Serres and Bruno Latour, *Conversations on Science, Culture, and Time,* trans. by Roxanne Lapidus (Ann Arbor: University of Michigan Press, 1995), 121.

resides for Serres the possibility of forms of understanding that can take into account the connections across time (past, present and future), places and scales in which we are implicated with others, both human and nonhuman, "living things and resonating things," which also "receive, transmit, store and process information."[35] An awareness of such relationships requires the recognition that "we exist within a whole natural system that is connected but its language has yet to be understood."[36] Attention, awareness and listening are thus key to what we can refer to, with Irigaray, as a "being-there" and "being-with." This encompasses the transience and continuity of life itself as well as the habitat in which we live—a way of being, in other words, that exceeds the narrow parameters of individual existence. Here, as Serres reminds us, the body "is not only for itself, it carries in itself for those that follow as well" through its genetic makeup that guarantees continuity across generations and temporalities.[37] Environments and habitats are also locations for which "we have to assume the responsibility of maintaining a merely temporary habitat, quite common to everyone across space and time, in order to pass it on to successors as habitable and beautiful as we received it from our predecessors" without soiling or appropriating it through contamination and violence; "we must live, in some way, at the same time there and outside the there, between here and elsewhere," in a continuation of time and space, "in the symbolic and the concrete, the second receiving meaning from the first."[38] Air and breath articulate the fluidity and entanglements argued by Serre where past and future are indissociable from the present, and where there is continuity between here and elsewhere, us and

35. Michel Serres, *Biogea,* trans. Randolph Burks (Minneapolis: University of Minnesota Press, 2012), 196.

36. Mary Zournazi, "Cosmocracy: A Hymn for the World? Reflections on Michel Serres and the Natural World," *Journal of Interdisciplinary International Studies* 9, no. 2 (2012): 1–9 at 6.

37. Serres, *Biogea,* 49.

38. Serres, 49–50.

others (in all their forms), meanings and matter.[39] Softness is the quality of this connectivity that for Serres has to be paired with an attitude of care toward the environment and the information that pervades it. This also entails a reassessment of knowledge and its ethics: "We will never attain a deontology of our knowledge and actions"—in Serres's words—"without thinking the subjective, the objective, the collective, and the cognitive all together simultaneously."[40] Emotion and affect are part of knowledge and action; they partake of modes of understanding whereby the effort of protecting the atmosphere also becomes one of critically acknowledging how the gaseous legacy of air implicates the contingency of its systemic contamination by the circulation of ideological as much as physical pollutants and pathogens. Information and critical understanding of the material and emotional consequences of vulnerability to air toxicity contribute to reframing contamination vis-à-vis forms of knowledge and doing that encompass being as breathing and its experiential as well as figurative meanings.

## "Running Out of Breath"

The Sars-CoV-2 pandemic has brought such issues to the fore, drawing attention not only to the correlation of air pollution and viral contamination but also to the complex intersecting of knowledge and doing around safe breathing. In his historical overview of pandemics from the H1N1 Spanish Flu viral infection in 1918 to the outbreak of Sars-CoV-2,[41] Mark Honigsbaum underlines the role of environmental, immunological, economic, social, and cultural

39. Serres, 89–92.
40. Serres, 71.
41. For the naming of the virus see World Health Organization nomenclature practices, see https://www.who.int/emergencies/diseases/novel-coronavirus-2019/technical-guidance/naming-the-coronavirus-disease-(covid-2019)-and-the-virus-that-causes-it. Throughout I shall refer to SARS-CoV-2 pandemic using both the official name of the virus and the commonplace name of Covid-19.

factors to the spreading of viral infections.[42] Deforestation and the expansion of farm land often result in the alteration of ecological habitats that facilitates the proximity of vectors of infection—such as bats—with livestock and humans, thus leading to potential contagion. Global trade and travel accelerate the spread of infectious diseases exponentially, while urbanization and more generally high-density demography together with high pollution levels and scarce sanitation further exacerbate viral transmission. The current climate crisis and pandemic are, in fact, "interfaced aspects, on different scales of time and space, of what is now chronic emergency."[43] Presumed to be linked to the Hunan Seafood Wholesale Market in Wuhan, a Chinese city of 11 million inhabitants, in which wild animal meat was also sold, "Covid-19 struck a world that"—in Honigsbaum's words—"had never been more interconnected setting off a chain of infections that crashed world stock markets, grounded international aviation, and silenced the most advanced cities in the world."[44] An airborne virus that can be contracted through direct or indirect contact, Covid-19 affects the respiratory system causing fever and dry cough, sore throat and bodily aches.[45] The picture Honigsbaum draws about the insurgence and spread of SARS-CoV-2—a new coronavirus—in December 2019 and the early months of 2020 is also one of political negligence and slow responses from local and national authorities worldwide, of reduced resources for healthcare and international research funding for the development of vaccines for coronavirus-related infections.[46] Early

42. Mark Honigsbaum, *The Pandemic Century: A History of Global Contagion from Spanish Flu to Covid-19* (London: Penguin Books, 2020), xiii–xix.

43. Andreas Malm, *Corona, Climate, Chronic Emergency: War Communism in the Twenty-First Century* (London: Verso 2020), 113.

44. Honigsbaum, *The Pandemic Century*, 262.

45. For causes of transmission, see https://www.who.int/news-room/commentaries/detail/transmission-of-sars-cov-2-implications-for-infection-prevention-precautions.

46. Honigsbaum, *The Pandemic Century*, 273.

warnings of the potential danger of a new pandemic from veterinary ecologists monitoring animal habits, from the World Health Organization and related monitoring programs such as ProMed were also systematically ignored.[47] In this volatile environment the entanglement of matter and meaning emphasizes more than ever the communality and singularity of each breath at the emergence of knowing, acting, and being.

At present, the state of Rancière's *indistinction* has figuratively choked the close environments of economics and geopolitics. The invisible matter of a virus—nothing more than a protein molecule that, by mutating the host cell, causes disease—has exposed the precarious interdependency of body politics (i.e., governments and health, social, and cultural institutions) and bodily needs as the essential condition for safe breathing and good health. The proximity and distancing that Irigaray recognizes as inherent in breathing has acquired a new ethical urgency as we practice social distancing and are reminded of the porous boundaries between our safety and that of others, the individual and communal relations of responsibility and coexistence.[48] In this climate, the spread of anxiety overlapping with viral contagion as fear is also part of the momentous encounter with our living environments affecting personal securities and public safety. Meanwhile, we continue breathing; ventilators and breathing protection masks have become nationwide issues of life and death, while oxygen shortages have put unprecedented pressure on health systems in Latin America (especially in Perù, Brazil, and Mexico), and in Asian and African countries, including India, Pakistan, Iran, and South Africa, with concerns in Laos, Nigeria, Malawi, and Zimbabwe.[49]

47. Honigsbaum, 270–73.

48. For a consideration in terms of choreography of the interrelation of proximity and distancing brought about by the SARS-CoV-2 pandemic through breath, see Kate Elswit, "Dancing with Our Coronasphere to Navigate the Pandemic," *Dance Magazine,* July 21, 2020, https://www. dancemagazine.com/six-feet-distance.

49. Madlen Davies and Rosa Furneaux, "Oxygen Shortages Threaten 'Total Collapse' of Dozens of Health Systems," *The Guardian,* May 25,

Access to breathing-support equipment, oxygen, and vaccination has sharpened the divides among those who are vulnerable across and within national borders. Everyone is reliant on safe breathing, yet we are increasingly confronted with the fragile interdependence of politics, economics, and well-being. Hence, the entanglement of the SARS-CoV-2 virus and the climate emergency are evidenced not only in the insurgence and spread of the infection but also in the ways in which it has been tackled. According to economists Abhijit Banerjee and Esther Duflo, "Vaccinating the world will be crucial if countries are going to act together to confront the climate crisis, which will require many of the same things as delivering vaccines: resources, innovation, ingenuity and true partnership between rich and developing countries."[50] Access to vaccine is, however, still unequal: at the end of April 2021 "less than 2% of the population of Africa has been vaccinated, while 40% of the population in the US and 20% of the population in Europe had received at least one dose."[51] Such disparity reflects the ingrained matrixes of power as well as the potential for change that the pandemic has brought to the fore. With Covid-19, a systemic mutation is occurring within the political and social cells of nation-states: economies are at

---

2021, https://www.theguardian.com/global-development/2021/may/25/oxygen-shortages-threaten-total-collapse-of-dozens-of-health-systems; Richard Pérez-Peña, "Why Some Hospitals Lack Oxygen to Keep Patients Alive," *The New York Times,* May 4, 2021, https://www.theguardian.com/global-development/2021/may/25/oxygen-shortages-threaten-total-collapse-of-dozens-of-health-systems. Lack of oxygen supplies affects all patients needing respiratory support, not only Covid ones. Hospitals in poorer areas rely on oxygen tanks, which are more expensive, rather than being directly connected to supplies via pipes, thus being especially vulnerable to shortages.

　　50. Abhijit Banerjee and Esther Duflo, "If We Can Vaccinate the World, We Can Beat the Climate Crisis," *The Guardian,* June 5, 2021, https://www.theguardian.com/commentisfree/2021/jun/05/poorer-nations-climate-promises-vaccines-vaccinating-covid.

　　51. Banerjee and Duflo.

risk and governments themselves panic at the levels of contagion. Suffocation makes its oppressive pressure tangible.

In an article published in *The New York Times* in April 2020 and reprinted in the collection of essays under the title, *Azadi* (2020), Arundhati Roy considers the responses to the spread of the SARS-CoV-2 infection in the United States and India, as both countries were struggling with its severity.[52] Roy underlines the historical rupture the pandemic has brought about and signals the opening of a portal between the recent past and postpandemic future. In her view, the danger is to seek a return to "normality"—to gravitate by default toward the past—rather than embracing the opportunity to imagine a different future. Roy's invitation for change resonates with Achille Mbembé's declaration for "the universal right to breathe" which was also published in April 2020.[53] According to Mbembé, the Covid-19 pandemic has brought us back to the body, to its physicality and mortality, to what it means to be a body that lives together with other bodies (including viruses) as part of ecosystems.[54] In Mbembé's words, "There is no doubt that the skies are closing in. Caught in the stranglehold of injustice and inequality, much of humanity is threatened by a great chokehold as the sense that our world is in a state of reprieve spreads far and wide," while there is also the potential for a break from the past and the possibility of radically reimagining a future of equality and justice for the community, or what he calls "the in common."[55] Breath as "the universal right to breathe" stands as both a bodily process and metaphor for such a state of being "in-common" and for life itself. Mbembé does not exclude the danger of the continuation of current geopolitics of exclusion, exploitation, and dominance, of what he refers to as "wars on life" that, not unlike SARS-CoV-2, suffocate,

52. Arundhati Roy, "The Pandemic Is a Portal," in *Azadi: Freedom, Fascism, Fiction* (London: Penguin Random House, 2020), 204–14.

53. Achille Mbembé, "The Universal Right to Breathe," trans. Carolyn Shread, *Critical Inquiry*, April 2020, https://critinq.wordpress.com/2020/04/13/the-universal-right-to-breathe/.

54. Mbembé.

55. Mbembé.

"taking the breath away"—whether in terms of the pillaging of re-
sources and environments, or of social, racial, and other forms of
inequality and injustice. He also postulates the breath as a catalyst
for rupture and renovation.

> Before this virus, humanity was already threatened with suffocation.
> If war there must be, it cannot so much be against a specific virus
> as against everything that condemns the majority of humankind to
> a premature cessation of breathing, everything that fundamentally
> attacks the respiratory tract, everything that, in the long reign of
> capitalism, has constrained entire segments of the world popula-
> tion, entire races, to a difficult, panting breath and life of oppression.
> To come through this constriction would mean that we conceive of
> breathing beyond its purely biological aspect, and instead as that
> which we hold in-common, that which, by definition, eludes all cal-
> culation. By which I mean, the universal right to breathe.[56]

Mbembé's return to the body resonates with Serres's and Irigaray's
embodied ethics whereby physicality stands as the inherent con-
dition of life, of being "in-common" in a web of inter- and intrare-
lations that each breath generates. But the body is also mortal and
fragile; it is the body that suffocates. The matrix of power relations
that governs the socioecological systems and the geopolitical cli-
mate in which SARS-CoV-2 has emerged and proliferates is one of
breathlessness: one that confronts us with an epistemic *running
out of breath* with historicity. To put it another way, the prevailing
suffocation and breathlessness underpinning contemporary toxic
atmospheres—whether due to pollution, pillage, extractivism, or
violence—underlines the shortcomings of established practices
of knowledge and understanding as well as of politics and eco-
nomics. A preservation of the gaseous legacy of the atmosphere
meets Mbembé's injunction of the universal right to breathe as an
aspiration—to borrow from Sharpe—for clear air and for what clear
air stands for: freedom, justice, and equality. Issues of visibility are
ever more present, as is the sense of urgency that characterizes the
gasping for air.

56. Mbembé.

# 3. Entanglements of Air

EXPANSIVE YET UNSETTLING VIEWS OF THE SKY, in which one has the impression of floating and being displaced at the same time, characterize the immersive environment of *Topologies of Air* (2021), a video and sound installation by Scottish-Danish artist, Shona Illingworth.[1] The work is a critical reflection on the economic and military colonization of airspace as well as its legal and cultural appropriation. Integral to *Topologies of Air* is the insight generated by the Airspace Tribunal,[2] a forum that uses the format of legal hearings where, in front of an invited jury, human rights lawyers, philosophers, activists, and scientists working in areas as diverse as ecology, psychology, and artificial intelligence, debate the potential recognition of a new human right "to protect the freedom

---

1. Shona Illingworth, *Topologies of Air* (2021), video and sound installation, https://thewappingproject.org/event/topologies-air-shona-illingworth/.

2. Shona Illingworth and Nick Grief, *Airspace Tribunal* (2018–ongoing), interdisciplinary forum http://airspacetribunal.org. The Airspace Tribunal is "a non-governmental tribunal set up by citizens—as such it challenges the traditional state centric view of how international law is created." E-mail communication with the artist, March 6, 2012. See also Nick Grief, Shona Illingworth, Andrew Hoskins, and Martin A. Conway, "The Airspace Tribunal: Towards a New Human Right to Protect the Freedom to Exist without a Physical or Psychological Threat from Above," *Digital War* (December 2020), doi: 10.1057/s42984-020-00023-w.

to exist without physical or psychological threat from above."[3] The Airspace Tribunal hearings are developed in collaboration with barrister Nick Grief, an expert in airspace and human rights who was part of the legal team that represented the Marshall Islands at the International Court of Justice in nuclear disarmament cases against India, Pakistan, and the United Kingdom. Between Autumn 2018 and Spring 2021, hearings of the Airspace Tribunal have been held in London, Sydney, Toronto, and Berlin. Central to the hearings is the belief that existing rights, including those "to life, liberty, and the security of person" are not sufficient "to protect people against threats experienced from or through airspace."[4] In particular,

> Developments in technology such as artificial intelligence and ma-
> chine learning to process big data collected via aerial surveillance,
> and increasing existential threats from nuclear weapons and envi-
> ronmental pollution, demand a radical and robust rights-based re-
> sponse befitting "the inherent dignity . . . of all members of the hu-
> man family," not forgetting the generations unborn.[5]

The "principle of action" that, as discussed in the previous chap-
ter, underpins a recognition of air as both a heritage and a shared
responsibility here translates into a discussion of the validity of a
new human right to protect the safety of airspace and air "as the
condition of and for embodied life."[6] While the right could be ex-
tended to include other species and life-forms, the hearings have
consistently stressed the serious psychological impact on civilians

---

3. Nick Grief, "The Airspace Tribunal and the Case for a New Human Right to Protect the Freedom to Live without Physical or Psychological Threat from Above," *Digital War,* October 12, 2020, https://doi.org/10.1057/s42984-020-00023-w; and Illingworth and Grief, *Airspace Tribunal,* http://airspacetribunal.org/.

4. Grief, "The Airspace Tribunal."

5. Grief, "The Airspace Tribunal."

6. Marijn Nieuwenhuis, "Atmospheric Governance: Gassing as Law for the Protection and Killing of Life," *Environment and Planning D: Society and Space* 36, no. 1 (2018): 78–95 at 80.

"of threats experienced from and through airspace" as they affect not only how one lives in the present but also how one imagines the future.[7]

In the London hearing held at Doughty Street Chamber on September 21, 2018, neuropsychologist Catherine Loveday described how the ability to imagine the future is closely related to the memory-imaging system and our ability to vividly recall the past.[8] Traumatic memories characterized by intense sensorial content powerfully shape traumatic imagining: "People who are anticipating a fearful event or trauma of some kind, or violence of any kind, or any kind of threat, are not just idly picturing it; they are to some extent living that experience."[9] The greater the lack of control and predictability, the more harmful are the psychological effects of unseen threats, as Loveday further explains, making children especially vulnerable.[10] In a Toronto-based hearing held online on November 4, 2020, Gabriele Schwab also focused her contribution on the abuse of air, whether due to air raids, nuclear disasters, or air pollutants, and the haunting emotional legacy of such abuse, both individually and intergenerationally, as our relationship with air is dominated by what Schwab regards as an ontological state of fear.[11] Ecological danger, biological warfare, and nuclear threat cause existential insecurity and foreclose the imagining of alternative futures through their latency.[12] For many, fear dominates their perception of the atmosphere, generating close, suffocating environments. According to Schwab, abuses of air and their consequences call for a reconsideration of the psychological and the

7. Grief, "The Airspace Tribunal."

8. Catherine Loveday quoted in Grief, "The Airspace Tribunal."

9. Loveday quoted in Grief, "The Airspace Tribunal."

10. Loveday quoted in Grief, "The Airspace Tribunal."

11. Gabriele Schwab, "The Airspace Tribunal," The Power Plant, Toronto, November 4, 2020, author's notes, https://www.thepowerplant. org/ProgramsEvents/Programs/Other-Programs/Airspace-Tribunal-(1). aspx.

12. Schwab, "The Airspace Tribunal," author's notes.

political as interconnected categories.[13] This resonates with our own analysis of how matter in the form of pollutants—but also risk and fear—subvert the inherent relation of breath to life, destabilizing it through the tangible and affective threats that pervade the atmosphere and imbue air with fear.

In this chapter, we shall expand the discussion on air pollution and issues of visibility by turning our attention to radioactive and chemical contamination. In particular we will focus on the video-documentary *The Radiant* (2012), by art collective Otolith Group, which examines the 2011 meltdown of the Daiichi Fukushima nuclear power plant in Japan vis-à-vis Japan's contradictory relationship to nuclear power. Issues of visibility are brought to bear on the intangible, contaminating presence of radioactivity and fear as equally latent and pervasive. This is further related to other forms of air violence and attacks on breathing through a consideration of Forensic Architecture's investigations into chemical airstrikes in Syria and the use of tear gas by police forces. Central to this chapter is a reflection on the politics of breathing at the intersection of forms of knowledge production and futurity.

**Contaminations**

Commissioned for Documenta 13 in 2012, Otolith Group's *The Radiant* deals with the aftermath of March 11, 2011, when the Tohoku earthquake off the east cost of Japan caused the partial meltdown of the Fukushima Daiichi nuclear power plant by focusing on the aftereffects of nuclear contamination through footage from a range of contemporary and historical sources.[14] These

13. Schwab, "The Airspace Tribunal," author's notes. Schwab further referred to 2020 as "the year of breath," alluding to the SARS-CoV-2 pandemic, the debate around face masks, and the chokehold on George Floyd—issues on which I will focus in chapter 4.
14. Otolith Group, *The Radiant* (2012), High Definition video, 64 min. Founded in 2002 by Kodwo Eshun and Anjalika Sagar, Otolith Group is known for its critical interdisciplinary collaborative practice in projects and

include images of the Fukushima event shot by observers and by scientists testing the levels of radiation on the site, satellite images and animations geared to families and children in visitor centers built around nuclear power stations to explain nuclear fission and its benefits. It also includes extracts from films about the testing of hydrogen bombs in the Bikini Atoll and the measurement of radiation levels in the 1950s. Through montage and temporal and spatial shifts, Otolith Group questions the unspoken forms of dominance and identification with energy that characterize atomic power and its futurity. The supposed safety of the Fukushima Daiichi power plant is contrasted with silent images of its explosion while journalist May Shigenobu observes, "Japan is becoming a guinea-pig for the effects of nuclear radiation [ . . . ] we are watching it and everyone else is watching Japan for the effects of this very dangerous material that we shouldn't be using anyway."[15] Under scrutiny, however, is what is essentially invisible: the effects of contamination on Japan's population—the genetic changes caused by radiation in present and future generations. *The Radiant* shows the now deserted village of Tomioka, which is part of the agricultural area affected by the radioactive spillage from the Fukushima Daiichi nuclear power plant. The inhabitants of Tomioka can return there for only a few hours per month. Here, an elderly farmer and antinuclear campaigner is one of the volunteers who expose themselves to the radiation for scientific study in order to detect its physiological effects. Past and

---

films that question the documentary form and engage with issues of futurity and transnationality. *The Radiant* is part of Otolith Group's ongoing investigation of the Anthropocene. As Eshun comments, "The Anthropocene gives us a different frame to understand the relations between scientific processes—whether those are atmospheric or geological—and human time." http://otolithgroup.org/index.php?m=project&id=143. For an account of the disaster, see Gabriele Schwab, *Radioactive Ghosts* (Minneapolis: University of Minnesota Press, 2020), 179–82; and Lucy Birmingham and David McNeill, *Strong in the Rain: Surviving Japan's Earthquake, Tsunami, and Fukushima Nuclear Disaster* (London: St. Martin's Press, 2012).

15. Otolith Group, *The Radiant*.

future conflate in the belated consequences of an event whose material presence can only be understood as affect and latency. Indeed, as Karen Barad argues, drawing from quantum theories, nuclear power and radioactivity upset linear understandings of time by positing the possibilities of multiple temporalities "where the 'new' and the 'old' might coexist," as "diffractively threaded through" and "inseparable one from the other."[16] Hence, the future is entwined with the past through the trace that the present generates:

> Our atomic past not only haunts the present, but is alive in the thickness of the here and now [ . . . ]. One manifestation of the fact "now" is shot through with "then" is the Fukushima disaster and its continuing consequences, which are directly entangled with the U.S. bombing of Hiroshima and Nagasaki.[17]

Barad relates Japan's postwar nuclear development for the production of energy as part of the U.S.-based Atoms for Peace Program and to the U.S. government's use of such a program "to shield the build-up of its nuclear arsenal during the Cold War," suggesting that "hauntings are an integral part of *existing* material conditions" and the making of both the present and the future.[18] As Barad argues,

> The entanglements of nuclear energy and nuclear weapons, nationalism, racism, global exchange and lack of exchange of information and energy resources, water systems, earthquakes, plate tectonics, geopolitics, criticality (in atomic and political senses), and more are part of this ongoing material history that is embedded in the question of Japan's future reliance on nuclear energy, where time itself is left open to decay.[19]

16. Karen Barad, "Troubling Time/s and Ecologies of Nothingness: Re-turning, Re-membering, and Facing the Incalculable," in *Eco-Deconstruction: Derrida and Environmental Philosophy,* ed. Matthias Fritsch, Philippe Lynes, and David Wood, 206–48 (Bronx, N.Y.: Fordham University Press, 2018), 221. https://doi.org/10.2307/j.ctt201mp8w.

17. Barad, 226.

18. Barad, 226–27.

19. Barad, 227.

In *The Radiant,* the accident in Fukushima is critically related to the reconstruction of Japan in 1945 in the aftermath of the atomic devastation of Hiroshima and Nagasaki. Archival film footage shows the black rain that drenched the atmosphere and soil at the time, and scientists collecting rainwater to measure the levels of radioactivity in a makeshift laboratory with a crowd of students pressing at the windows. In another sequence, scientists in a field surrounded by farmers measure the radioactivity of crops. Otolith Group juxtaposes this archival film footage with close-up shots of faces wearing different kinds of breathing masks—from a 1940s gas mask worn during air raids to a contemporary antiradioactive one—thus symbolically linking the alarming consequences of air raids and radiation in the postwar period to the present. This connection is further accentuated in an extensive sequence that follows the visit of a scientist to the zone of the nuclear power station as a camera lingers on the contaminated debris. What emerges is an analysis of how the postwar restoration of Japan's national identity as well as its economic and geopolitical power were identified with nuclear energy. The attempt to emulate American techno-science led in fact to the extensive construction of nuclear power plants all over the country. The concerted political and economic efforts of reconstruction rearticulated the traumatic legacy of the atomic attacks and their lasting transgenerational effects by presenting nuclear power as a form of potency with an ironic guarantee of safety, capable of supporting Japan's national pride and its aspirations to international hegemony.

*The Radiant* reflects on how a mythology of nuclear power has nourished a nationalist vision of empowerment and an ideology of futurity in which techno-scientific knowledge has been key, and how such a mythology has partly contributed to the repression of the traumatic historical legacy of the postwar period. The long temporality of radioactivity thus translates into the belatedness of trauma as an after-affect whose duration lingers at the boundaries of past and future knowledge, as a site of both repetition and unknowability. While techno-scientific understanding can monitor

nuclear power, the duration of radioactive contamination refers to an impending trace whose past is imbued with alienating otherness and whose future is the belated actualization of such traces as mutation, disease, and decay. Terror as the shock of what has happened and what could happen instigates rather than mitigates an apprehensive disavowal of the physical and emotional presence of radioactivity.

We are reminded of Gabriele Schwab's notion of "nuclear necropolitics"—a concept Schwab draws from Achille Mbembé—to suggest the political denial of the threat to life posed by nuclear power.[20] This for Schwab is embedded in colonial practices of extraction and is evident in the psychological colonization, in itself a form of contamination, of people's minds.[21] As Peter Sloterdijk remarks, it is as if the "political-psychological and moral lessons of the twentieth century were given to empty classrooms" by contemporary democracies that are "blind in their acute penchant for forming closed atmospheres and for according excessive importance to the hallucinatory systems built by victors."[22] In *The Radiant,* such blindness is evoked by the visual citation of a video that went viral on social media at the time of the accident in Fukushima. The video extract shows one the workers at the power plant, Kota Takeuchi, pointing an accusatory index finger at the surveillance camera. Takeuchi—a performance artist in his own right—openly quotes a close-up of Vito Acconci holding the same gesture in the 1971 video, *Centers.* Here, Acconci's self-referential gesture is recast as both a defiant accusation against those who supported the proliferation of nuclear energy and an act of grievance for the poor working conditions at the power station,[23] overtly alluding to the intricate mesh

20. Schwab, *Radioactive Ghosts,* 18–26.

21. Schwab, 26.

22. Peter Sloterdijk, *Terror from the Air,* trans. Amy Patton and Steve Corcoran (Los Angeles: semiotext(e), 2009), 105. See also Bruno Latour, "Air," in *Sensorium: Embodied Experience, Technology, and Contemporary Art,* ed. Caroline A. Jones, 105–7 (Cambridge Mass.: MIT Press, 2006).

23. T. J. Demos, *Decolonising Nature,* 253–55.

of responsibility and economic exploitation that characterizes the "closed atmospheres" of governments and corporations.

Otolith Group further translates the hallucinatory system that justifies the production of nuclear energy into the scenario of the glowing night lights in Tokyo that are generated by it. *The Radiant* juxtaposes these lights with infrared images of the contaminated landscape around the Daiichi power plant filmed with a camera capable of recording electromagnetic radiation as luminescence. "The film shows light produced by nuclear energy that is normally not visible, even while radiation functions as an imperceptible actor in its midst, suffusing the atmosphere."[24] These grainy, black-and-white images together with the haunting sound of a Geiger counter capture the infra-sensible lingering of radioactivity as matter that pervades the atmosphere with physical danger that cannot be disentangled from the ideology and politics that mythologize it. Nor can it be disentangled from fear as its emotional counterpart. According to Barad, this physical and (from my perspective) affective trace of matter is part of an ongoing material history of temporal diffraction and decay, but also of the discursive erasure enacted by the selective production of historical knowledge; the encroachment of radioactivity on safety, like the overlaying of past events onto the future, superimposes its own violence and horror.[25] The devastation and trauma caused by the nuclear bombings of Hiroshima and Nagasaki are in fact meshed with the no less traumatic legacy of the air raids, fires, and destruction suffered by most Japanese cities in the last year of the Second World War (1944–45), in which an estimated 410,000 people died.[26] The verbal and visual representations of the extensive bombing by the U.S. Air Force that targeted mainly

24. Demos, 249.
25. Barad, "Troubling Time/s," 224–27.
26. Natsuko Akagawa, "'Difficult Heritage,' Silenced Witnesses: Disremembered Traumatic Memories, Narratives, and Emotions in Japan," in *Places of Traumatic Memory*, ed. Amy L. Hubbell, Sol Rojas-Lizana, Natsuko Akawaga, Annie Pohlman, 37–59 (Basington, UK: Palgrave Macmillan, 2020), 40.

civilians described Japanese cities as "an abstract enemy space" devoid of people,[27] thus exempting the horror of these air-raids in the public perception. Historical erasure continued with the post-war attention given to the atomic bombings and their supposed "justification" in the "resilient narratives of the 'good war'" that led to an unwillingness to question and engage with the ethical implications of the large-scale targeting of civilians that had preceded them.[28] At the same time, the concurrent attempt of Japanese governments to present the country as a champion of international peace and disarmament has clouded, if not intentionally suppressed, the trauma suffered by the Japanese people.[29]

While the damage from air raids on Japan is gradually gaining belated historical recognition both nationally and internationally, relevant for our discussion is the threat with which they have endangered the atmosphere. The traumatic traces of these airstrikes along with those of the atomic bombings of Hiroshima and Nagasaki determine the latent foreboding represented by radioactivity and its consequences. As Barad argues, "Memory is not merely a subjective capacity of the mind rather, 'human' and 'mind' are part of the landtimescape—spacetimemattering—of the world. Memory is written into the worlding of the world in its specificity, the ineliminable trace of the sedimenting historicity of its iterative reconfiguring."[30] "Worlding" and "sedimenting" also involve air and our responsibility for its safety and futurity on which breathing is predicated. Radioactivity challenges notions of temporality because its duration exceeds any conceivable understanding of history. Radioactivity, in other words, defies conceptions of temporal scale because of the inconceivable extent of what we know about its consequences. It also conflates the very possibility of a macro/micro dichotomy by

27.  David Fedman and Cary Karacas, quoted in Akagawa, "'Difficult Heritage,'" 46.
28.  Fedman and Karacas quoted in Akagawa, 46.
29.  Akagawa, "'Difficult Heritage,'" 46–47.
30.  Barad, "Troubling Time/s," 239.

encompassing vastness and permanence, not to mention nuclear fission and genetic mutation. With radioactivity, the macroscale of ecological damage merges with the molecular level of matter and with different forms of knowability, which accounts for the transgenerational durability of radioactive contamination and its affect. "This challenge to scale"—according to Schwab—"also affects how we think the boundaries of human subjectivity and communication. At stake is nothing less than the reach of affect and emotion, moral thought and action across vast scales" and within the infinitesimally small.[31] In this sense, radioactivity is paradigmatic for an understanding of other forms of contamination, whether in relation to air pollution or air violence. The historical and affective sedimentation that characterizes it also concerns abuse of air more generally and what is perhaps its most indiscernible consequence: the vulnerability of breathing.

## Toxic Air and the Politics of Breathing

According to Sloterdijk, since the beginning of the twentieth century the atmosphere has been "denaturalized" and increasingly imbued with terror.[32] Sloterdijk locates the beginning of such denaturalization during the First World War, when chlorine gas was used by "a specially formed German gas regiment" against French-Canadian troops at Ypres Salient on April 22, 1915.[33] An aerial photograph documents the toxic cloud caused by the chemical weapons, illustrating a newly established target and combat zone: "the enemy's environment."[34] Elsewhere I have examined the overlapping of chemical and affective contamination as docu-

31. Schwab, *Radioactive Ghosts*, 211.
32. Sloterdijk, *Terror from the Air*, 9. See also Paul Virilio, *War and Cinema: The Logistic of Perception*, trans. Patrick Camiller (London: Verso, 2009); Sven Lindqvist, *A History of Bombing*, trans. Linda Haverty Rugg (London: Granta, 2012).
33. Sloterdijk, *Terror from the Air*, 9–10.
34. Sloterdijk, 16.

mented by rare archival film footage of the use of chemical weapons authorized by Benito Mussolini—despite the League of Nations' international ban—during the Italian invasion of Ethiopia in 1935–36 in airstrikes that indiscriminately targeted Ethiopian troops and civilians.[35] A sequence shows the dropping of chlorine bombs on a village, the landscape devastated by the contaminating chemical cloud, the corpses of people who died from its effects, flames destroying a hospital tent and doctors trying to treat those whose flesh had been burned by the gas.[36] Relevant for our discussion is the inextricability of ecological and psychological harm attested by these images, and the issues of visibility that this raises. It is such visibility that is at stake when we are dealing with the "ontological fear"—to use Schwab's phrase—that air contamination in its diverse manifestations and scale poses.

The proliferation of biological and chemical weapons has, in fact, jeopardized breathing, rendering it a war target in ways that accentuate the vulnerability to toxic air within geopolitical contexts. This transpires in the ambiguity that terms such as "risk," "threat," "safety" or "security" have acquired in relation to air, bringing to the fore what Marijn Nieuwenhuis refers to as the politics of breathing to suggest that "breath contains knowledge and therefore politics."[37] Air, for Nieuwenhuis, "reveals a history and a politics in itself. It is already infused with memories, chemicals, and other things of the past. Neither do we passively stay within one air. We

35. Caterina Albano, "Forgotten Images and the Geopolitics of Memory: The Italo-Ethiopian War (1935–6)," *Cultural History* 9, no. 1 (2020): 72–92, doi: 10.3366/cult.2020.0209. Only in 1992 did the Italian government recognize responsibility for the use of chemical weapons. See Simone Belladonna, *Gas in Ethiopia: I Crimini Rimossi dell'Italia Coloniale* (Vicenza: Rizzoli, 2015), 25.

36. Lutz Becker, *The Lion of Judah, War in Ethiopia 1935–1936* (1975), documentary film based on archival film footage, Imperial War Museum, Film Archive, London, MGH 2624.

37. Marijn Nieuwenhuis, "Atemwende, or How to Breathe Differently," *Dialogues in Human Geography* 5, no. 1 (2015): 90–94 at 91.

are constantly and intermittently thrown into different, new and old airs."[38] Accordingly, the politics of breathing pertains to the everyday as it is "centred on the concealed thing we unknowingly inhale, exhale, and share with others and the world on an everyday basis."[39] Ecological violence and conflict render air ever thicker with histories and politics and as a consequence amplify the need to address and substantiate them.

The generation of evidence capable of counteracting the invisibility of the violence perpetrated against civilians through abuses of air is central, as suggested, to the practice of the multidisciplinary research agency Forensic Architecture.[40] Relevant for our discussion are Forensic Architecture's investigations in substantiating the use of chemical gas against civilians perpetrated by Bashar al-Assad's regime in Syria. These include investigations into the chemical attacks on the towns of Khan Sheikhoun (April 4, 2017,), on Al Lataminah (July 30, 2017) and on the city of Duoma (April 7, 2018), as well as an investigation into a U.S.-based company's production of Triple-Chaser tear gas and other instances presented in the video *Cloud Studies* (2020).[41] In 2017 the two towns of Khan Sheikhoun and Al Lataminah were the targets of alleged chemical attacks that the Syrian authorities and their allies subsequently denied.[42] Using photogrammetry, Forensic Architecture was able to draw on images and data collected on the respective sites to create 3D models of the munitions and crates that produced the explosions to confirm their causes. In the case of the attacks on Al Lataminah, in particular, it was during a press conference that the Russian foreign ministry provided ballistic information on the typologies of chemical weap-

38. Nieuwenhuis, 91.
39. Nieuwenhuis, 92.
40. Weizman, *Forensic Architecture*, 9.
41. Forensic Architecture, https://forensic-architecture.org/.
42. Forensic Architecture, Investigation Khan Sheikhoun I. 23, 2017, https://forensic-architecture.org/investigation/chemical-attack-in-khan-sheikhoun; Investigation Al Lataminah I.41, 2017, https://forensic-architecture.org/investigation/chemical-attacks-in-al-lataminah.

ons used in Syria, offering clues for a comparative analysis of the debris of the bombs found in Al Lataminah that helped to confirm the chemical attack. Similarly, on April 7, 2018, the city of Douma, which had been under siege by the Syrian military since 2013, was allegedly the target of two chlorine gas attacks.[43] One explosion hit a rooftop balcony near Al Shuhada square, while the other one hit a bedroom in another location of the city. Russian reporters were the first to have access to the city after its surrender days later. They claimed that both attacks had been staged by the occupying forces and had not been caused by the Syrian regime's airstrikes. To support an inquest led by *The New York Times,* Forensic Architecture was able to build 3D modelling of the sites and of the munitions confirming that the canisters found matched the characteristics of those used in other chlorine gas attacks. It was also assessed that the first explosion had been caused by a bomb dropped most likely from a helicopter, while the data about the second one remained inconclusive.

Explaining the approach of Forensic Architecture, its founder, Eyal Weizman, remarks that buildings are like "the sensors" of historical and environmental changes as they bear the traces of transformation. "Records of the interaction of the atmosphere with buildings," he observes, "are deposited in layers of dust and soot on their facades, and their microstratigraphy can provide a rich archaeological resource for a study of urban air, containing information about $CO_2$, lead, or toxins in the atmosphere—a vestige of history of industrialization, transportation, and attempts at regulating them."[44] Buildings also record signs of habitation and forms of detonations and ruptures, sediments of chemical contamination, and the dynamics of explosions. Hence, the layering of history that buildings account for is both one of exposure to external processes and one of abrupt disintegration. They act as

43. Forensic Architecture, Investigation Duoma, I. 34, 2018, https://forensic-architecture.org/investigation/chemical-attacks-in-douma.

44. Weizman, *Forensic Architecture,* 52.

sensors of interference and of the forms that interference can take
as repositories of information. Not unlike media, buildings are
"both storage and inscription devices that perform variations on
three basic operations that define media: they sense or *prehend*
their environment, they hold this information in their formal mu-
tations, and they can later diffuse and externalize effects latent in
their form."[45] Buildings thus present traces of information to be
identified and interpreted within a network of other data, images,
and verbal reconstructions. These include the potency of muni-
tions and their characteristics that, as in the cases considered, can
be regarded as "agents of affect" for the physical destruction and
contamination they cause, but also for their emotional impact on
the life within the buildings. Here, as Forensic Architecture's re-
constructions suggest, matter and meaning interact sideways at
the margin of visibility and accountability through processes of
recognition, reconstruction, and interpretation. In contemporary
warfare, as Weizman observes, the state is responsible for crimes
such as the use of chemical weapons on civilians that it also denies,
whilst private organizations undertake investigations to prove the
state's culpability "by engaging with a condition of structural in-
equality in access to vision, signals, and knowledge to find ways
to operate close to and under the thresholds of detectability."[46]
Such thresholds of detectability intersect with others, whether
juridical, territorial,[47] or one might add, ethical. The consequences
of the alleged use of chlorine gas in Syria perpetrated by the gov-
ernment on its citizens goes in fact beyond the temporality of the
events themselves and of its poisonous residues; it is a history of
ingrained oppression as a latent corrosive presence contaminat-
ing the living environment of Khan Sheikhoun, Al Lataminah, and
Duoma, a layer of history deposited on their buildings and in the
deepest tissues of their inhabitants' bodies.

45. Weizman, 53.
46. Weizman, 30.
47. Weizman, 31.

"My family is inside. Go on the roof! Close the doors, close the doors! He is dumping chlorine [ . . . ] No one should breathe," reads the translation of the dialogue in a video filmed on the ground during a chemical attack in Aleppo on December 8, 2018, included in *Cloud Studies*.[48] The survivors of these attacks describe "a yellow-greenish cloud affecting sense perceptions, causing blurred vision, difficulty of breathing, vomiting, and excess salivation."[49] Breathing in such conditions is imbued with suffocation, as journalist and film director Waaded Al-Kateab remarks about her experience of extensive airstrikes during the government siege of Aleppo in 2016, when she felt oppressed by fear and an inability to breathe.[50] In this loop of violence and suffocation, the attacks in Syria also generated an "information cloud" of images, analysis, and counteranalysis that upset the tenuous boundaries of visibility and invisibility surrounding the chlorine attacks by obfuscating evidence of crimes, "dissipating denial through discord," and dislocating online debates.[51] The mediatic cloud of information also partakes of contemporary atmospheres by exerting pressure, producing "closed environments," and ambiguously clouding the safe boundaries of breathability. Forensic Architecture counteracts the abstraction and dissipation of toxic clouds in their mediatic counterpart by generating a different kind of image and knowledge—one that by addressing the politics of breathing puts in the foreground the experience of breathlessness and suffocation.

The cloud of dust caused by the Israeli bombing of the Gaza Strip—the 2008 investigation of which opens *Cloud Studies*—"contains everything that the building once was: cement, plaster, plastic, glass, timber, fabric, paperwork, medicines, sometimes parts

48.  Forensic Architecture, *Cloud Studies*, 2020, video, voiceover, https://forensic-architecture.org/investigation/cloudstudies.

49.  Forensic Architecture, *Cloud Studies*, voiceover.

50.  Waat Al-Kateab and Edwards Watts, *For Sama*, 2019, documentary film, produced by Waat Al-Kateab, United States, United Kingdom, Syria.

51.  Forensic Architecture, *Cloud Studies*, voiceover.

of human bodies."[52] As he speaks on the phone with members of
Forensic Architecture's team in London, a witness of the airstrike
coughs repeatedly because of the smoke dust he is breathing, con-
veying the extent to which civilians are the target of the Israeli
operations in the region.[53] In *Cloud Studies,* Forensic Architecture
further relates these attacks to the dropping of white phosphorus in
the Gaza Strip by Israeli planes that cause mysterious flashes in the
sky capable of burning anything they might come into contact with
and leaving poisonous residues in the air. Low-flying Israeli planes
are also shown spraying herbicides containing glyphosate (a sub-
stance banned for its toxicity) along the border with Gaza, where the
wind pushes the glyphosate cloud toward Gaza. Seasonally repeat-
ed, these clouds destroy Palestinian crops, putting the livelihoods
of local inhabitants at risk by contaminating the ground. They also
produce a barren area along the border where no vegetation grows,
which facilitates Israeli surveillance of the region. Ecological con-
tamination and military occupation intersect, lingering as material
and affective traces that render breathing ever more vulnerable in
the Gaza Strip. Such violence, as Ilan Pappe observes, "has a his-
tory and an ideological infrastructure" rooted in colonial ideology
and practices that entangles past and future, and, as in the case of
nuclear power, generates its sedimented legacies.[54]

In *Cloud Studies,* these investigations intersect those into de-
forestation and into the methane cloud emission produced by oil
fracking in Vaca Muerta in Argentina. Only detectable by infrared
cameras, toxic methane emissions contaminated the living envi-
ronment of the indigenous Mapuche community, endangering
their livelihood and upsetting their very relationship with the land
and the atmosphere, suggesting the generation of what Forensic
Architecture refers to as a "negative common." The protest of the

52. Forensic Architecture, *Cloud Studies,* voiceover.
53. Forensic Architecture, *Cloud Studies,* voiceover. See also Ilan
Pappe, *Ten Myths about Israel* (London: Verso, 2017), 304–5.
54. Pappe, *Ten Myths about Israel,* 161–62.

Mapuche against such contamination was stopped with further contamination in the form of tear gas. Evident across Forensic Architecture's investigations of toxic clouds, from Israel's airstrikes in the Gaza Strip to the deployment of chlorine bombs in Syria and that of tear gas to stop civil demonstrations in places as diverse as Hong Kong, Cairo, Istanbul, and the Mexican border with the United States, are the ways in which air as a condition of life is exposed. The coercive control and contamination of air as a means of colonial oppression in the Gaza Strip suggests a depletion of air meant to undermine agency. In these conditions, breathlessness becomes a form of domination. The autonomy that breathing symbolizes is itself undercut by gassing. Breathlessness can thus be understood as a physical impairment, as the powerlessness that fear induces, and as the crippling of human rights. Contrary to breathing, breathlessness alienates, since it differentiates between those who have access to air and those who do not, deferring and even preventing action as an enforced form of paralysis. The withdrawal of air infers invisibility through the denial of agency and autonomy.

Also included in *Cloud Studies* is a project commissioned by and presented at the 2019 Whitney Museum Biennial that directly implicates the vice chair of the Museum's board of trustees who owns the Safariland Group, one of whose companies produced the tear gas grenades used by U.S. border agents against civilians in November 2018.[55] As Forensic Architecture's investigation explains,

> Whereas the export of military equipment from the US is a matter of public record, the sale and export of tear gas is not. As a result, it is only when images of tear gas canisters appear online that monitoring organizations and the public can know where they have been sold, and who is using them.[56]

To facilitate the recognition of these images, Forensic Architecture has developed a project using computer vision recognition to train a

55. Forensic Architecture, Investigation Triple-Chaser, I. 43, 2018, https://forensic-architecture.org/investigation/triple-chaser.
56. Forensic Architecture, Investigation Triple-Chaser, I. 43.

machine classifier to detect Safariland tear gas canisters using as a test sample a grenade known as a Triple-Chaser. Despite its prohibition in warfare and the severe health damage it can cause, including breathing difficulties, pulmonary edema, convulsion, and danger of impaired breathing, tear gas is commonly used by governments worldwide to stop civil demonstrations. Indeed, the Triple-Chaser has been known to be used against civilians in countries such as Turkey, the United States, Israel, Palestine, Egypt, Yemen, Bahrain, Iraq, Peru, Venezuela, and Canada. Not unlike the investigations into the use of chemical gas in Syria, objects—in this case the Triple-Chaser grenade—function as vectors of information that, once decoded, can be used to generate further information able to contest much of the withholding and denial that surrounds the use of tear gas and the assumption of its being "nonlethal." By entering "the experiential conditions of optical blur and atmospheric obscurity" within clouds, Forensic Architecture's investigations also disclose the resistance that the politics of breathing generate as collective political action "by the inhabitants of tear gas around the world."[57] Out of vulnerability can also emerge endurance. Contrary to the foreclosure that abuses of air cause, these investigations envisage the potential of common action and solidarity. *Cloud Studies* concludes by quoting Achille Mbembé's call "to hold *in-common* the universal right to breathe."[58]

57. Forensic Architecture, *Cloud Studies*, voiceover.
58. Forensic Architecture, *Cloud Studies*, over-script.

# 4. To Suffocate: The Politics of Breathing

A GAS MASK CARVED IN MARBLE displayed on a marble surface (2013) by Chinese artist Ai Weiwei formally pays homage to both the modernist tradition of the readymade and to ancient reliquaries.[1] Part of a series of everyday objects carved in marble or jade—materials associated respectively with European and Chinese classical sculpture—Weiwei's marble mask alludes to the high levels of pollution in Chinese cities and the normalization of the hazard toxic air poses to breathing. It signifies protection against an impinging danger but also acts as a muted critique of the economics, politics, and social issues that, as discussed in chapter 2, underpin air pollution. The specific choice of marble as the material for this sculpture, typically associated with memorials and monuments, renders this ordinary object a *memento mori* of our time. The display suggests a skull resting on a tomb, both an evocation of vulnerability to air pollution and of the invisibility of breathlessness itself. The associations this gas mask evokes, however, go beyond air pollution to encompass other forms of contamination caused by abuses of air. Weiwei's marble mask acts as a metonym for the breathing body itself, for the physicality of inhalation and exhalation, and for how

1. Ai Weiwei, *Mask*, 2013, marble, https://www.lissongallery.com/exhibitions/ai-weiwei—3.

breathing has increasingly become a site of governance mediated by technologies that in turn enable or impede it. The SARS-CoV-2 pandemic has further exposed the politics of breathing "as an aggressive and catastrophic affirmation of existing socio-economic logics; an intensified continuation of the rule rather than a break with it."[2] The entitlement to breathe, to "the universal right to breathe,"[3] remains a thorny issue.

This chapter focuses on the politics of breathing in terms of the inequalities and harm caused to breathing by state powers and policing vis-à-vis breathlessness and suffocation. Drawing on our discussion on contamination, we return to the intersubjective relations established by breathing and consider the invisibility of breathlessness and suffocation across colonial paradigms and ecological and decolonial perspectives. By considering the emblematic significance of breathing masks, such as face masks and gas masks, the chapter further explores the entanglement of contamination, histories, and ethics in undermining safe breathing. It does so by following two different, though I believe interwoven threads of argument. The first thread regards the politics of breathing that emerged in the first months of the SARS-CoV-2 pandemic and that are still current a year later; the other thread relates back to the analysis on abuses of air developed in chapter 3 through the analysis of Kurdish artist Hiwa K's *This Lemon Tastes of Apple* (2011), a video of his performance on the last day of a protest in Sulaymaniyah (Iraq) during the Arab Spring when tear gas was used against the demonstrators. Harnessing the discussion on an ethics of breathing, the chapter further questions the use of the chokehold as a form of policing that led to the deaths by suffocation of Eric Garner and George Floyd.

2. Maria Chehonadskih and Andrés Saenz De Sicilia, "Subject: The Global Distribution of the Ethical," June 2020, https://works.raqsmediacollective.net/index.php/2020/06/08/31-days-june-2020/.

3. Mbembé, "The Universal Right to Breathe."

**Face Masks and the Ethics of Breathing**

In May 2020, following the enthusiastic reaction to a photograph showing a wood carving printed on a face mask that Ai Weiwei had posted on Instagram, the artist developed a project using face masks in collaboration with curator Alexandra Munroe.[4] He had 10,000 nonsurgical cloth face masks silk-screened by hand with images based on some of his past works, including sunflower seeds, mythological figures, and a raised middle finger, to be sold on eBay. The proceeds from the sale went to Covid-19 emergency humanitarian and human rights groups. Weiwei's project was a direct response to the controversies the SARS-CoV-2 pandemic ignited around the use of face masks, including the accusation of "modern piracy" against the U.S. government after it was reported to be "diverting a shipment of masks intended for the German police, and outbidding other countries in the increasingly fraught global market for coronavirus protective equipment."[5] As Weiwei commented, "It is such a waste. There is so much argument around the mask. A face mask weighs only three grams but it carries so much state argument about global safety and who has it and who doesn't have it."[6] Face masks are, indeed, emblematic of the thick net of implications around protection and vulnerability, sovereignty and restriction that SARS-CoV-2 has brought to the fore individually and collectively, at the level of the nation-state and geopolitics.

With the slow recognition of the insurgence of the SARS-CoV-2 pandemic and the reluctance to take adequate measures to prevent

4. Ai Weiwei, *Mask Project*, 2020, Press Release, Lisson Gallery, London, July 13, 2020, https://www.lissongallery.com/news/ai-weiwei-launches-art-project-to-raise-funds-for-covid-19-humanitarian-causes. Ai Weiwei also realized a film, *Coronation* (2020), on how the pandemic was handled in China.

5. Mark Brown, "Ai Weiwei Creates 10,000 Masks in Air of Coronavirus Charities," *The Guardian*, May 28, 2020, https://www.theguardian.com/artanddesign/2020/may/28/ai-weiwei-creates-10000-masks-in-aid-of-coronavirus-charities.

6. Ai Weiwei, quoted in Brown, "Ai Weiwei Creates 10,000 Masks."

its spread, the use of face masks in public places and its legislation have often been slow and contested.[7] The divided opinion of scientists on their potential usefulness in limiting the spread of airborne droplets converged with political uncertainty and public dissent. In the United States, the imposition of face masks in public places was seen as an infringement of individual freedom and a "muffling" of civil liberties, polarizing public opinion in ways that often reflected the factions of the already fierce political presidential electoral campaign, thus turning the wearing of face masks into a political football while the country was struggling, at the time, with high Covid-19 infection rates.[8] In the United Kingdom, in the first months of the pandemic, Chinese communities were stigmatized for wearing face coverings—a standard practice in countries like China, Japan, South Korea, or Taiwan. In Japan, for instance, the wearing of face masks—whether due to pollution or potential infection—is a socially embedded practice that developed as a response to a wider and diffuse "culture of risk."[9] More generally, the debate around face

7. Lauren Aratani, "How Did Face Masks Become a Political Issue in America?," *The Guardian,* June 6, 2020, https://www.theguardian.com/world/2020/jun/29/face-masks-us-politics-coronavirus; Benjamin Mueller, "After Months of Debate, England Requires Face Masks for Shoppers," *New York Times,* July 14, 2020, https://www.nytimes.com/2020/07/14/world/europe/uk-coronavirus-masks-mandate.html; Graham P. Martin, Esmée Hanna, Margaret McCartney, and Robert Dingwall, "Science, Society, and Policy in the Face of Uncertainty: Reflections on the Debate around Face Coverings for the Public during COVID-19," *Critical Public Health,* 30, no. 5 (2020): 501–8, https://doi.org/10.1080/09581596.2020.1797997; Helene-Mari van der Westhuizen et al., "Face Coverings for Covid-19: from Medical Intervention to Social Practice," *The British Medical Journal,* August 19, 2020, https://doi.org/10.1136/bmj.m3021.

8. Martin Pengelly, "US Sets World Record for Coronavirus Cases in 24 Hours," *The Guardian,* October 31, 2020, https://www.theguardian.com/world/2020/oct/31/us-world-record-coronavirus-cases-24-hours.

9. Westhuitzen et al. "Face Coverings for Covid-19"; Adam Burgess and Mitsutoshi Horii, "Risk, Ritual, and Health Responsibilisation: Japan's 'Safety Blanket' of Surgical Face Mask-wearing," *Sociology of Health Illness* 24, no. 8 (November 2012): 1184–98. doi: 10.1111/j.1467-9566.2012.01466.x pmid: 22443378.

masks in different countries has been rife with political inflections and contradictions, despite the difficulty hospitals faced in dealing with the surge of infections, and the shortages of protective equipment and ventilators. Meanwhile, the reality of the respiratory difficulties caused by the virus and its related deaths were—and still are—either abstracted in daily official figures, or brought to our attention through the personal accounts of patients and health workers that have circulated on social media.[10] These antithetical attitudes toward face masks are turned onto themselves and given different political resonances by Chinese performance artist Brother Nut, who used surgical masks with the inscription "shut up" as well as metal clasps, tape, and gloves to silence himself as a sign of protest against the Chinese government's censorship of information regarding the spread of the SARS-CoV-2 infection.[11] During his thirty days of silent protest Brother Nut turned his face mask into a sign of political resistance and a mute assertion of freedom of expression indirectly pointing to the vacuity of the "Western" debate. Within this context, the contradictory associations to which face masks lend themselves are indicative of how the Covid-19 pandemic is also implicated in the politics of breathing and its broader ramifications.

In January 2021, as new variants of the virus are spreading and vaccination programs are underway, face masks are still crucial. A scientist at the Pasteur Institute in Lille reportedly stated on French Radio the possibility of making PPE masks mandatory in France: "As the variant is more easily transmitted, it is logical to use masks with the highest filtering power. We are not questioning the masks used up to now . . . but as we have *no new weapons* against the new

10. For an account of the medical experience in the first months of the pandemic in the United Kingdom, see Rachel Clarke, *Breathtaking: Inside the NHS in a Time of Pandemic* (London: Little, Brown Book Group, 2021).

11. Sarah Cascone, "Chinese Artist and Activist Brother Nut Is Taking a Vow of Silence to Protest Government Censorship of Coronavirus Data," *Artnet*, July 21, 2020, https://news.artnet.com/art-world/brother-nut-silent-pandemic-protest-1896045. In chapter 2, we referred to Brother Nut's 2015 project on air pollution.

strains, the only thing we can do is to improve *the weapons* we already have."[12] Relevant here is not the mandatory adoption of PPE masks but rather the military analogy: face masks as weapons. This analogy resonates with the official military rhetoric often used during epidemics—especially by politicians—that is reminiscent of wartime.[13] Accordingly, nations are effectively "at war" with the ever-present yet imperceptible "enemy," the infectious virus. I would like to question such rhetoric and consider it in relation to the debate ignited by the use of face masks.

To infect, from the Latin verb *inficire,* meaning "to put in, to stain, or to dye,"[14] conveys the idea of penetration and the diffusion of a pathogen, from which the adjective *infectious* and the noun *infection* also derive as an expression of the power of pathogens to affect. Such terminology testifies to the cultural construction of infectious diseases and by extension of epidemics as "invasions" that have to be fought. For some people, the uncertainties and changes experienced during the Covid-19 pandemic have been a cause of anxiety, doubt, and suspicion, as "we may distrust the air we breathe and the surfaces we touch, while strangers suddenly seem unpredictable sources of potential danger."[15] Military analogies can intensify such

12. Quoted in Jon Henley, Kate Connolly, Kim Willsher, and Daniel Boffey, "France May Follow Germany in Making Clinical Masks Mandatory," *The Guardian,* January 20, 2021, https://www.theguardian.com/world/2021/jan/20/france-may-follow-germany-in-making-clinical-masks-mandatory. Emphasis added.

13. In the UK, Boris Johnson's rhetoric had deliberate military overtones that channeled his hero, Winston Churchill's Second World War speeches with a similar attempt at mobilization and generating nationalist feeling.

14. "Infection," *Merrian-Webster Dictionary,* https://www.merriam-webster.com/dictionary/infection.

15. Havi Carel, Matthew Radcliff, and Tom Froese, "Reflecting on Experiences of Social Distancing," *The Lancet,* 396 (10244), July 30, 2020, 87–88 at 88, doi: 10.1016/S0140–6736(20)31485–9. For an analysis of the complex relations between pathological breathlessness and feelings of safety, see Kate Binnie, Coreen McGuire, and Havi Carel, "Objects of Safety and Imprisonment: Breathless Patients' Use of Medical Objects

a state of apprehension and mistrust that calls for "defense" and "safety" but can also lead to the opposite reaction, that of denial and "invincibility." Fear is mobilized as emotional currency and framed within a rhetoric of "armament" and "victory," drawing the focus exclusively to the self—whether as individual, group, or nation-state—implicitly stressing one's own breathing and one's freedom to breathe in ways that contradict the fact that we share the air we breathe and the commonality that breathing establishes. It is an aggressive response that supports an unequal distribution of breathing.

This has proved to be pernicious. The death rate from Covid-19 in UK prisons has, for instance, been more than three time higher than in the rest of the population, and in the United States it is 45 percent higher than in the overall population.[16] Moreover, "long-standing health disparities affecting ethnic minorities in the UK have been made acutely visible by the COVID-19 pandemic": data published by Public Health England reported that deaths among these groups were "two to four times greater than those among the White population in England."[17] In the United States, the American Public Media Research Laboratory has estimated "a death rate 1.7

in Palliative Setting," *Journal of Material Culture,* 26, no. 2 (2020), doi: 10.1177/1359183520931900.

    16.  Jamie Grieson, "Covid Death Rate in Prisons Three Times Higher than Outside," *The Guardian,* March 16, 2021, https://www.theguardian.com/society/2021/mar/16/covid-death-rate-in-prisons-three-times-higher-than-outside; Mary Van Beusekom, "Studies Detail Large COVID Outbreaks at US Prisons Jails," *CIDRAP,* April 5, 2021, https://www.theguardian.com/society/2021/mar/16/covid-death-rate-in-prisons-three-times-higher-than-outside; Beth Schwartzapfel, Katie Park, and Andrew Demillo, "1 in 5 Prisoners in the U.S. Has Had Covid-19," *The Marshall Project,* December 18, 2020, https://www.themarshallproject.org/2020/12/18/1-in-5-prisoners-in-the-u-s-has-had-covid-19.

    17.  Daniel R. Morales and Sarah N. Ali, "Covid-19 and Disparities Affecting Ethnic Minorities," *The Lancet,* April 30, 2021, https://www.themarshallproject.org/2020/12/18/1-in-5-prisoners-in-the-u-s-has-had-covid-19.

greater for Afro-American than that of Indigenous American and
2.3 times that of white and Asian American."[18] Systemic racial dis-
crimination as well as socioeconomic segregation and underlying
chronic medical conditions are among concurring factors suggest-
ing the persistence of historical patterns of epidemic morbidity
bound up in cultural biases.[19] In France and Europe in general,
discrimination toward migrants and foreigners has been especially
acute toward Asian groups, whereby "'racisme sanitaire' is reflected
in discourse, attitudes, and behavior that invokes suspicion and
rejection toward tourists, migrants, residents and citizens of very
distant Asian origin."[20] While reflecting on the dramatic situation in
India in April 2021, during the peak of the pandemic's second wave,
Arundhati Roy denounces the collision of Indian Prime Minister
Narendra Modi's politics, to which the persecution of non-Hindu
ethnic minorities and political opponents is integral, with his re-
sponse to the pandemic.[21] She draws attention to hospitals being at
breaking point "with people dying in hospital corridors, on roads
and at their home" and oxygen having become "the new currency"
on India's stock exchange.[22] Modi, who has modeled his governmen-
tal approach on European nationalist leaders of the early decades
of the twentieth century,[23] has underplayed the seriousness of the

18.  Mohammad S. Razai, Hadyn K. N. Kankam, Azeem Majeed, Aneez
Esmail, David R. Williams, "Mitigating Ethnic Disparities in Covid-19 and
Beyond," *British Medical Journal,* January 14, 2021, https://www.bmj.com/
content/372/bmj.m4921.

19.  Razai et al.

20.  Simeng Wang, Xiabing Chen, Yong Li, Chloé Luu, Ran Yan,
and Francesco Madrisotti, "'I'm More Afraid of Racism than of the
Virus!': Racism Awareness and Resistance among Chinese Migrants
and Their Descendants in France during the Covid-19 Pandemic,"
*European Societies* 23, supplement (2020), S721–S742 at S723, doi:
10.1080/14616696.2020.1836384.

21.  Arundhati Roy, "We Are Witnessing a Crime against Humanity,"
*The Guardian,* April 28, 2020, https://www.theguardian.com/news/2021/
apr/28/crime-against-humanity-arundhati-roy-india-covid-catastrophe.

22.  Roy.

23.  Pankaj Mishra, *Age of Anger: A History of the Present* (London:
Penguin Books, 2017), 342–43.

situation, taking on the Western government rhetoric of aggression while displaying callousness to the suffering and deaths of millions.[24] When the virulence of the infection eventually eases, Roy observes, "The rich will breathe easier. The poor will not," as an inevitable continuity of a status quo.[25] The cultural construction of the pandemic as an "invasion" and the related "protectionist" and "defensive" manifestations have maintained, if not swelled, corrosive atmospheres of suffocation. Covid-19 seems, in fact, to have drawn attention to the breath only superficially, obfuscating ever more the inequalities that surround breathing and what can be regarded as the invisibility of systemic states of breathlessness and suffocation. As Abhijt Banerjee and Esther Duflo comment, "Despite all the talk of solidarity at the beginning of the pandemic, rich countries built sufficient capacity only to produce enough vaccines for themselves and then proceeded to corner the world supplies."[26] The cultural sedimentation of aggressive metaphors of infectiousness thus suggests ingrained frameworks in the articulation of diseases, their causes and the interrelations not only between humans and pathogens, but more conspicuously those defining the inequalities among social and ethnic groups and political forms of prevarication. The virus, not unlike Serres's parasite, is both organic and informational matter, the molecular element of a relationship and the instigator of changes to it.[27] The ways in which we read, describe, and act all count in producing our cultural formulations.

According to Isabelle Stengers, scientific knowledge is constructed around favoring the observation and analysis of some phenomena

24. Roy, "We Are Witnessing a Crime against Humanity."

25. Roy.

26. Abhijt Banerjee and Esther Duflo, "If We Can Vaccinate the World, We Can Beat the Climate Crisis," *The Guardian,* June 5, 2021, https://www.theguardian.com/commentisfree/2021/jun/05/poorer-nations-climate-promises-vaccines-vaccinating-covid.

27. Michel Serres, *Parasite,* trans. Lawrence R. Schehr, with an introduction by Cary Wolfe (Minneapolis: University of Minnesota Press, 2007), 190–96.

to the exclusion of others: this results in partial articulations of
the multilayered spectrum of factors that characterize experience,
including the interrelations within ecosystems of humans and oth-
er species.[28] Extending Stengers's consideration of the discursive
articulation of human interaction with pathogens, another image
of infection comes to mind. In *My Memory* (2017), Taiwanese artist
Cemelesai Dakivali (Arsai) depicts fantastic forms of sinuous ten-
tacled viruses in which scientific imaging merges with Taiwanese
mythological motifs.[29] The work stems from an incident that hap-
pened in the South of Taiwan some years ago, when "a group of
young people from his tribe contracted a mysterious disease after
a field research [trip] in their traditional territories. This incident
reminded Dakivali of the legends told by elders that certain terri-
tories should be protected from any human intervention."[30] The
resulting images of *My Memory* visually synthesize the overlapping
of modern science and traditional lore as complementary ways of
making sense of the mutually affective interrelation of humans
and pathogens. Dakivali "reverses the logic of the invasive species,
where humans venturing in the forest are the main factor of disrup-
tion and are attacked back in a retroactive loop."[31] His strange and
menacing creatures do not undermine the risk of infection. On the
contrary, they reveal the possibility of another metaphor for it, one
underscored by the interrelation of humans and pathogens that re-
positions infection within the multilayered spectrum of experiential
factors and the dynamics of interaction and affect. This, according
to Michel Serres, implies not regarding "others" including microor-

28. Isabelle Stengers, *Cosmopolitics I,* trans. Robert Bononno
(Minneapolis: University of Minnesota Press, 2010), 34–36.

29. Cemelesai Dakivali (Arsai), *My Memory,* 2017, engraving,
*Critical Zones: Observatories for Earthly Politics,* Center for Art and
Media Karlsruhe, ZKM, 23.5.2020–8.8.2021, https://zkm.de/en/exhibi-
tion/2020/05/critical-zones.

30. "Encounters," in *Critical Zones: Observatories for Earthly Politics,*
exhibition cataglogue (Karlsruhe: Center for Art and Media Karlsruhe,
ZKM), 28.

31. "Encounters," in *Critical Zones,* 28.

ganisms as "enemies in a battle, but as symbionts and mutualists,"[32] involving a process of knowing that does not seek victory—it is not "against" microorganisms—but instead develops "with" them through a deciphering of the signs that they convey.[33] Hence, the images we use for talking about viruses, including those of combat, need to change, as they themselves are the parasite that we carry in our theoretical knowledge, technologies, and practices: viruses are no longer enemies in a "race of mutation and invention," dominance and defeat, but rather the participants of mutual exchanges.[34] By asking "How can the invasive order become a reciprocal dialogue?"[35] Serres restores the inseparability of matter, bodies, and meanings, the intra-actions of air, pathogens, and ourselves and of ourselves with all and everyone "other." By positioning infection within affective frameworks of interrelations, freedom to breathe also acquires different connotations; safe breathing no longer refers solely to protecting one's own breathing but a way of "breathing-with" as shared responsibility through the air we breathe "in-common," as an agent of the life and knowledge that circulate through it. Pathogens are also participants of such "in-common"[36] in which there are no vanquishers and losers. This suggests "attending" to the breath intersubjectively, as action and resistance, refuting images of invasion in order for us to reimagine "safety" through new images that can help us make breathing safe and equal.

### Vulnerable Breaths

Protective breathing masks allude to both a means for safe breathing and its endangerment. French artist Arman's 1960 sculpture, *Home,*

---

32. Michel Serres, *Biogea,* trans. Randolph Burks (Minneapolis: University of Minnesota Press, 2012), 170.

33. Serres, 171–72.

34. Serres, 169–70.

35. Serres, 172.

36. Mbembé, "The Universal Right to Breathe."

*Sweet Home,* an "accumulation" of gas masks in a glass box, testifies to the antithetical significance of such an apparatus.[37] The work is a reminder of the horror of warfare, alluding to the airstrikes that had wrecked European cities during the Second World War as well as to the drills that civilians would undergo with such masks in preparation for potential gas attacks. The work, not unlike Ai Weiwei's mask, is also reminiscent of a reliquary that sinisterly evokes Nazi death chambers where inmates were asphyxiated with toxic gas. The gas mask thus acts as a modern trope of the histories and politics that pervade air with their threat and of the vulnerability of breathing itself. Such histories, as Marijn Nieuwenhuis observes, are rooted in colonial practices aimed "to discipline the body" of those who were regarded as "others."[38] Accordingly, "While breathing bodies enjoyed certain legal rights in the 'civilized' West, atmospheric governance worked very differently in other 'savage' and 'law-less' parts of the world."[39] Nieuwenhuis offers a historical analysis of such practices and argues that a "historisation of gassing reveals a great deal about whose right to life is legally protected and whose rights are suspended; who is allowed to access air and who is not; who is inside and who is outside law."[40] To put it another way, such historical perspective reveals the unequal distribution of breathing that the control of air exercises on individual bodies and peoples.

Today's ongoing use of chemical warfare as well as the deployment of tear gas betrays a similar governance and control of air aimed at impeding or suppressing breathing. As our discussion of

37. Arman (Armand Fernandez), *Home, Sweet Home,* 1960, gas masks, wooden box, and plexiglass, Centre Pompidou, Paris, https://www.centrepompidou.fr/en/ressources/oeuvre/5BZeCMj.
38. Marijn Nieuwenhuis, "Atmospheric Governance," 83. See also Miguel de Larrinaga, "(Non)-lethality and War: Tear Gas as a Weapon of Governmental Intervention," *Critical Studies on Terrorism,* June 16, 2016, 522–40, https://doi.org/10.1080/17539153.2016.1197626.
39. Nieuwenhuis, "Atmospheric Governance," 83.
40. Nieuwenhuis, 85.

*Cloud Studies* suggests, attacks on breathing are not limited to war zones but are widespread instruments of policing as "the preferred technology of state power to discipline, punish, and immobilise breathing bodies."[41] At stake is the supposed "nonlethality" of tear gas and the ethical implications that such an assumption generates in legal terms, since "arguing from the principle of non-lethality helps toward expanding the legal realm of punishing bare life *right up to until the point of its killing.*"[42] The supposed nonlethality of tear gas is haunted by suffocation as the underlying specter of the very act of breathing. Hence, as Nieuwenhuis argues, "the atmosphere becomes itself an extension of the logic of sovereignty" since gassing "makes the significance of the relationship between body and air *explicit,*"[43] rendering breathing "a political relation between the body and the sovereign power that can switch on and off the atmospheric conditions for its animation."[44] Such a relation and its implications resonate with Hiwa K's video, *This Lemon Tastes of Apple,* in which the toxic legacy of ethnic oppression manifests as breathlessness.[45]

The video opens in a market in Azadi Square in Sulaymaniyah on April 17, 2011, with images of men wearing face masks and holding halved lemons or bottles of water in their hands. The protest had already lasted for two months and, as the artist recounts in an interview with Anthony Downey, nine people had died and five hundred had been wounded.[46] That day the stage that was used for speeches had been burned down and there was shooting: "The people were scared and they didn't want to lose their lives,"

---

41. Nieuwenhuis, 89.
42. Nieuwenhuis, 89.
43. Nieuwenhuis, 90.
44. Nieuwenhuis, 91.
45. Hiwa K., *This Lemon Tastes of Apple,* 2011, video performance, http://www.hiwak.net/projects/lemon-tastes/.
46. Hiwa K., "Performative Resonances: Hiwa K. in conversation with Anthony Downey and Amal Khalaf," interview by Anthony Downey, *Ibraaz,* July 30, 2015, https://www.ibraaz.org/interviews/171.

remembers Hiwa K, "but after this attack they started to go back and I thought it was the moment that we could revitalize the protest one more time."[47] The artist himself is shown playing Ennio Morricone's soundtrack for Sergio Leone's film *Once upon a Time in the West* (1966) on his harmonica as he walks. An elderly man chants a slogan in front of him. Smoke is visible in the background. A man shows a handful of bullets to the camera. Tear gas explodes in the midst of the crowd; people gag under the suffocating effect of the gas. Hiwa K himself has to stop playing to cover his face with a towel, before starting again. Lemons are passed around so the juice can be used to relieve the burning sensation in the mouth and nose. One man chokes and the sound of his suffocating breath mixes with that of the harmonica. Lemon juice is squeezed in his mouth. As the demonstration continues, more explosions are heard, and an injured man is helped by others wearing face masks; the commotion increases and then gradually the crowd disperses. The camera lingers on the blood-stained ground as feet move away.

The title of Hiwa K's video references Saddam Hussein's genocidal campaign against the Kurds in 1988, when his troops deployed gas against civilians; survivors of the attack reported the gas smelled of apples. It also alludes to the lemons shared during the demonstration in Sulaymaniyah.[48] Sensory perception mixes with the traumatic repetition of breathlessness and suffocation: both the physical harm to breathing produced by the gas and the repression of freedom and national identity experienced on an individual scale by civilians who became the target of their own authorities. In *This Lemon Tastes of Apple,* even the tune Hiwa K plays on his harmonica, as he observes, "has a deadly rattle."[49] The tune alludes to the expansionistic origins of the United States in its suppression

---

47. Hiwa K., "Performative Resonances."
48. Hiwa K., "Performative Resonances."
49. Hiwa K., "Performative Resonances."

of Native American people and to the making, under the pretext of liberation, of the modern myth of global, political, and economic hegemony that underscores abuses of air. "When tear gas is being fired at you," remarks Hiwa K, "and when you play the harmonica, you must inhale and exhale to make that melody, so that was also a death rattle of sorts as I was breathing in gas."[50] Hiwa K's haunting rattle on the harmonica marked by his gasping breath rhythmically paces his performance and confers on it what the artist refers to as its "deadly" playfulness as a "way to engage with people" and stir action, teasing a web of associations that relate not only to the persecution of the Kurds in Iraq but that extend to other persecutions and other attacks on breathing perpetrated by state powers. In this sense, what Judith Butler argues about the poems written by prisoners in Guantanamo and their primeval connection to survival—"to the arithmetic of breathing in and out"[51]—could be extended to Hiwa K's performance and to other instances of breathlessness and suffocation: despite the apparent impotence against oppression, these expressions "do provide the conditions for breaking out of the quotidian acceptance of war and for a more generalized horror and outrage that will support and impel calls for justice and an end of violence."[52] It is from this need to break out from acceptance of oppression and to impel justice that resistance to the politics of breathing arises. It is a need that is integral to the rhythm of the breath itself, a need to breathe out of breathlessness and to reclaim the autonomy to breathe. It is as much a cry for justice and equality as a call for safe air—in the various entangled meanings that safe air can signify—and an end to political and ecological violence. In this cry, the question of how to account for those who live in a state of breathlessness is and remains pressing.

50. Hiwa K., "Performative Resonances."
51. Judith Butler, *Frames of War: When Is Life Grievable?* (London: Verso, 2009), 10.
52. Butler, 11.

## "I Can't Breathe"

In John Akomfrah's film, *Handsworth Songs* (1986), we hear a
conversation between two women.[53] One of them tells her friend
how she had been stopped and chokeheld by police officers during
a demonstration. The woman is Black, the officers were white.
Produced by the Black Audio Film Collective, *Handsworth Songs*
explores the events surrounding the 1985 riots in Birmingham and
London through a montage of archival film footage, still photos, and
newsreel. As another woman comments in the film when answering
a journalist who asks her about the unrest, "There are no stories in
the riots, only ghosts of other stories."[54] Among the ghosts of those
other stories suffocation looms large. Such ghosts encompass the
lingering legacies of slavery and colonialism, of systemic racial vio-
lence and discrimination, and the entangled legacies of gassing and
of the unequal distribution of breathing to which the governance
of air subjects individual bodies and peoples.

To discuss the pervasive climate of racial discrimination in the
United States, Christina Sharpe refers to the weather, a weather
imbued with the ghosts of slavery.[55] By reflecting on slavery through
a meteorological analogy—as a condition of the air itself and of the
ecologies it produces—Sharpe alludes not to "the specifics of any
event or set of events that are endlessly repeatable and repeated"
but to "the totality of the environments in which we struggle, and
machines in which we live."[56] Sharpe asks, "when the only certainty
is the weather that produces a pervasive climate of antiblackness,
what must we know in order to move through those environments

53. John Akomfrah, *Handsworth Songs,* 1986, film, https://www.tate.
org.uk/art/artworks/black-audio-film-collective-handsworth-songs-t12862;
see also British Film Institute http://www.screenonline.org.uk/film/
id/441093/index.html.

54. Quoted in Akomfrah, *Handsworth Songs.*

55. Christina Sharpe, *In the Wake: On Blackness and Being* (Durham,
N.C.: Duke University Press, 2016), 104.

56. Sharpe, 111.

in which the push is always toward Black death?"[57] The insidiousness of racial discrimination and systemic violence also manifests in the toxic politics of breathing and the governance of Black bodies implemented through suffocation. The oppressive climate Sharpe describes regards air both as matter and meaning, as "the necessity to breathe" as well as "the necessity of breathing space" and of "breathing spaces in the wake in which we live"[58]—a wake haunted by breathlessness.

In her analysis, Sharpe recounts the incident on Staten Island on July 17, 2014, when Eric Garner, an African American man was chokeheld by a police officer after having been stopped in the street on the suspicion of illegally selling single cigarettes. Garner repeated eleven times "I can't breathe" before he stopped breathing.[59] His desperate words became the rallying cry of protests against the invisibility and invalidation of civil rights for African American people in the United States when a grand jury declined to press criminal charges against Garner's assailant. Sharpe relates Garner's killing to the pervasiveness of suffocation as a means of policing in the United States, citing examples of police enforcement, death by suffocation in prisons, and that of fifty people asphyxiated in the cargo hold of a ship.[60] In commenting on Eric Garner's killing, Jerome Roos also emphasizes such a climate of systemic violence, stating, "We can't breathe in this toxic atmosphere of state brutality. We can't breathe in this travesty of justice, this sham of a democracy."[61] Roos extends his outrage to other instances of asphyxiation and police violence—

57. Sharpe, 106.

58. Sharpe, 109.

59. Sharpe, 110. See also Franco (Bifo) Berardi, *Breathing: Chaos and Poetry* (South Pasadena Calif.: semiotext(e), 2018), 15; and "Eric Garner: NY Officer in 'I Can't Breathe' Death Fired," https://www.bbc.co.uk/news/world-us-canada-49399302.

60. Sharpe, *In the Wake*, 111–13.

61. Jerome Roos, "From New York to Greece, We Revolt 'Cus We Can't Breathe,'" *ROAR Magazine,* December 7, 2014, https://roarmag.org/essays/eric-garner-protests-we-cant-breathe/.

including gassing—in France, Hong Kong, Turkey, and Palestine and
calls on the commonality of breathing as shared responsibility for
breaking such a state of suffocation. However, despite public outcry
and critical reflection, breathlessness remains a form of control
and coercion. On May 25, 2020, George Floyd was also chokeheld
by police officers and died after repeating twenty-seven times "I
can't breathe."[62]

Although the deaths of Garner and Floyd have drawn attention to
the fierce, systemic climate accounted for by Sharpe, breathlessness
as a form of both physical control and a means to terrorize remains
mostly invisible. In examining violence and forms of self-defense,
Elsa Dorlin argues that oppression persists in the bodies of those
who suffer it as negative cognitive behaviors and fearfulness.[63]
Fear manifests as hypervigilance and anxiety, while cognitive and
behavioral self-defensive attitudes include bodily postures and
movements meant to lessen, deflect, avoid, or dissipate oppression
by making oneself almost invisible.[64] Breathlessness thus appears
as a sign of ingrained intergenerational trauma as an embodied,
acquired response to oppression. It is as if one learned to lessen its
stranglehold of power by figuratively withdrawing oneself from
air. It is, in other words, as if the breather had internalized the
"de-animation" implicit in the governance of air. In breathlessness
we can recognize an intimation of Frantz Fanon's notion of "zones
of nonbeing,"[65] since it stands both for a denial of the ontologi-
cal link to life represented by the breath and a disavowal of the
epistemological significance that the breath carries as a definer

62. Kenya Evelyn, "FBI Investigates Death of Black Man after Footage
Shows Officer Kneeling on his Neck," *The Guardian,* May 27, 2020, https://
www.theguardian.com/us-news/2020/may/26/george-floyd-killing-po-
lice-video-fbi-investigation.

63. Elsa Dorlin, *Se défendre: Une philopsophie de la violence* (Paris:
Zones Éditions Le Découverte: 2017), 17.

64. Dorlin, 175.

65. Frantz Fanon, *Black Skin, White Masks,* trans. Charles Lam
Markmann (1952; London: Pluto Press, 1967), 2.

of subjectivity and commonality, of the relationships between self and others. "Under these conditions" of oppression, writes Fanon, "the individual's breathing is an observed breathing. It is a combat breathing."[66] It is a breathing that embodies both vulnerability and resistance. According to Judith Butler, "precarity is indissociable from that dimension of politics that addresses the organization and protection of bodily needs. Precarity exposes our sociality, our fragile and necessary dimension of interdependency."[67] Considered in relation to Butler's claim, breathing thus resides within an ethical discourse not despite but rather because of its vulnerability vis-à-vis the control and abuse of air. At the same time, suffocation shatters the foundations of an ethics of breathing by exposing its intrinsic vulnerability. With Sharpe, we might well ask, "what is the word for keeping and putting breath into the body?"[68] What are the words, images, and approaches for addressing the entangled histories of breathlessness and today's suffocation?

In discussing Garner's death—though the arguments apply also to Floyd's—Marijn Nieuwenhuis explains how the chokehold has been reformulated in U.S. police departmental guidelines and qualified as a side effect of a "less-than-lethal manoeuvre" that, as he states, "'inadvertently' allows and legitimizes for an attack on the vital lifeline of the body."[69] Breathing becomes physiologically secondary in legal and, by extension, in epistemological and political determinations. "The elemental act of breathing is, in other words," as Nieuwenhuis remarks, "relegated as something that falls outside of law altogether."[70] By maintaining the conditions for the governance

66. Sharpe, *In the Wake*, 113.
67. Judith Butler, "Bodies in Alliance and the Politics of the Street," *Transversal Text,* September 2011, https://transversal.at/transversal/1011/butler/en.
68. Sharpe, *In the Wake*, 113.
69. Marijn Nieuwenhuis, "A Right to Breathe," *Critical Legal Thinking,* January 19, 2015, https://criticallegalthinking.com/2015/01/19/right-breathe/.
70. Nieuwenhuis, "A Right to Breathe."

of air and legitimizing suffocation, this falling outside the law of breathing is central to an understanding of the politics of breathing. Nieuwenhuis compares the legal invisibility of the chokehold as an attack on breathing to that already observed for chemical attacks on civilians and the deployment of tear gas to control protests or social unrest, urging us to consider ways in which our right to breathe can be protected and exercised.[71] In his words, "A right to air, it bears remembering, is not the same as a right to life,"[72] since air is a condition that enables life itself. Nieuwenhuis is concerned with the invisibility of breathing in legal terms. Drawing on Butler, such invisibility indicates the precarity of the body, its exposure to vulnerability and its implications.[73]

The relevance of a right to breathe is today ever more pressing as breathing continues to be targeted. Tear gas was used during the protests that followed Garner's death in 2014 and was also deployed in the summer of 2020 during the Black Lives Matter demonstrations after Floyd's death to protest against and call for the end to systemic racial violence in the United States. As a report by Amnesty International states, protesters were met by the repeated use of "physical force, chemical irritants such as tear gas and pepper spray, and kinetic impact projectiles."[74] The report continues by stressing,

> The use of tear gas during the COVID-19 pandemic is especially reckless. As protestors took to the streets, wearing masks and attempting to socially distance due to the virus, police fired tear gas

71. Nieuwenhuis, "A Right to Breathe."
72. Nieuwenhuis, "A Right to Breathe."
73. Judith Butler, "Rethinking Vulnerability and Resistance," in *Vulnerability in Resistance*, ed. Judith Butler, Zeynep Gambetti, and Leticia Sabsay, 12–27 (Durham, N.C.: Duke University Press, 2016).
74. Amnesty International, "USA: Law Enforcement Violated Black Lives Matter Protesters' Human Rights, Documents Acts of Police Violence and Excessive Force," August 4, 2020, https://www.amnesty.org/en/latest/news/2020/08/usa-law-enforcement-violated-black-lives-matter-protesters-human-rights/.

and pepper spray, escalating risks for respiratory issues and the release of airborne particles that could spread the virus.[75]

The same could be said of the use of tear gas during demonstrations in Hong Kong in the summer of 2020 or the farmers' protests in Delhi in January 2021. The recklessness in deploying tear gas during a viral pandemic that affects the respiratory system shows the impossibility of separating breathing and breathlessness on every possible level—whether we consider it epidemiologically in terms of potential virus transmission, of the health risks that both tear gas and SARS-CoV-2 present, or ethically for putting lives at risk, negating freedom and the autonomy of breathers themselves. Such recklessness also evidences racial and ethnic discrimination given the high incidence of infection among Black and Asian groups, and the impact on access to treatment of social inequalities. As suggested, the pandemic has put a magnifying glass on breathlessness as a means of governance, disclosing an entangled template of causes and effects but also of knotted affects and overlapping scales. To use Butler's terms, it has shown "how bodies are being acted on" by policing as well as by social and economic forces.[76] Hence, as discussed in relation to ecological contamination and toxic violence, we are confronted with how we think about breathing, and, to use Gabriele Schwab's words, how we think about "the reach of affect and emotion, moral thought and action"[77] across places and different manifestations of abuse. We are also confronted with how we think about the breathing body in its relations with other bodies and environments, how we recognize such bodies in relation to air, both in the present and the future.

Breathlessness, however, also has its affect. For Butler, vulnerability is not a condition but rather a relation to experience, forces,

75. Amnesty International, "USA: Law Enforcement Violated Black Lives Matter Protesters' Human Rights."

76. Butler, "Rethinking Vulnerability and Resistance," 15.

77. Gabriele Schwab, *Radioactive Ghosts* (Minneapolis: University of Minnesota Press, 2020), 211.

and emotions that affect the individual; "vulnerability is a kind of relationship that belongs to that ambiguous region in which receptivity and responsiveness are not clearly separable from one another, and not distinguished as separate moments in a sequence."[78] Vulnerability of breathing thus ensues within the interaction of bodies, environments, and toxicity as well as of politics, affect, and action and, as Butler argues of vulnerability more generally, it also entails resistance in "those practices of deliberate exposure to police or military violence"[79] of which the exposure to tear gas is an instance. The suffocation of Garner and Floyd has affected and moved bodies, pushing them to challenge the politics of breathing through their own breathlessness, through what Butler would regard as "the mobilization of their vulnerability."[80] They have aroused impassioned calls for justice and an end to violence and suffocation. Breathlessness has brought about an affirmation of breathing. The word that Sharpe found "for keeping and putting breath back in the body," and specifically "in the Black body" is "*aspiration*"[81]—a word that also resonates with Mbembé's call "to hold in-common the universal right to breathe."[82] Mbembé stresses the imperative need for change to counteract breathlessness and the persistence of the politics of breathing, suggesting that a return to established "normality" will mean to succumb once again to breathlessness—as vulnerability to pollution, unequal distribution to such resources as vaccines, or as the continuation of abuses of air. How can we then aspire to breathing, how can we imagine a response to Mbembé's call? This question requires thought and action; it requires space to breathe.

A right to breathe, "the universal right to breathe" is first and foremost an embodied right. It is a right that emerges from the

78.  Butler, "Rethinking Vulnerability and Resistance," 25.

79.  Butler, 26.

80.  Butler, 13.

81.  Sharpe, *In the Wake,* 113.

82.  Mbembé, "The Universal Right to Breathe."

vulnerability of breathing that is also the vulnerability of the body itself. Because we share air with others (human and nonhuman) it is a right that includes individuals and ecosystems as inseparable. It has the force of an aspiration but also the softness of tranquil, unharmed breathing. Breath has also distinct rhythmic cadences and motions, hence a right to breathe is perhaps a verbal rather than a written right, a right that can encompass unicity and commonality in its own articulation, a right that attends to the breath as matter and meaning: a right that is voiced and breathed.

I began my reflection on breath with the image of a paper bag that contained breathed air and its crumpling sound as air moved in and out of it. I would like to conclude with the sound of the breath and voice of artist and poet Anaïs Duplan. In *You Take My Breath Away: A Sonics Freedom* (2020),[83] Giorgio Moroder's song, increasingly distorted, is layered with the background sound of coughing and gasping. The coughing intensifies, meshed with sighs and panting. One feels sonically engulfed in breathlessness. From choking and acoustic deformation, Duplan's distinct voice surfaces until its sound is also broken and compressed as they ask, "Can I pursue liberation? What kind of liberation can I pursue?"[84] Duplan seeks resistance in art, in the unresolved "tension between thought and matter," in an art that redefines paradigms and "rewrites theory with experience."[85] Such art is evoked by sensory images like childhood memories prompted by the aroma of a bakery, by the continuous immersion and interaction with one's surroundings. But such environments can feel "alternatively supportive" and "hostile."[86] The precarity of life is haunted by "the ghosts of other stories"; for Duplan it takes the form of dreaming of lynchings and "the fear"

83. Anaïs Duplan, *You Take My Breath Away: A Sonics Freedom,* 2020, voice and sound, https://parrhesiades.com/Ana%C3%AFsDuplan.html.
84. Duplan, *You Take My Breath Away.*
85. Will Harris "What Kind of Liberation?," 2020, https://parrhesiades.com/Ana%C3%AFsDuplan.html.
86. Duplan, *You Take My Breath Away.*

the artist forces themself to live in. "How can art help us be free, in the words of Audre Lorde, through the chaos of knowledge?"[87] In asserting that "sense is meaning," because "without sense there is no volition, notion, participation, or communication,"[88] Duplan reclaims embodied knowledge in its individuality yet beyond difference and duality, almost in breathing itself, in its being both matter and meaning, singularity and plurality. They affirm the intimate connection of sense and meaning in the sonic texture of the work, through the layered sonorities of the soundtrack, the cadences of voice and the grainy presence of breathing. From this texture, integration emerges as air, in their words, "in this single world substance, everywhere is home, everything is forever and everyone is inalienable."[89] For me, *You Take My Breath Away* speaks of "the universal right to breathe." In giving a voice to it, Duplan breathes it.

87. Duplan, *You Take My Breath Away*.
88. Duplan, *You Take My Breath Away*.
89. Duplan, *You Take My Breath Away*.

# Acknowledgments

At Central Saint Martins, University of the Arts London, I would like to thank Professor Tom Corby, associate dean of research, for his encouragement when I first mentioned the idea of a book on breath. Thank you also to the colleagues and students there who create such a vibrant and creative working environment, to Jamie Brassett and Marketa Uhlirova with whom I have shared responsibilities and Debi Kenny for her wonderful support.

I would also like to acknowledge University of Minnesota Press and the editorial team for their help. I am especially grateful to Professor Gabriele Schwab for her generous review of the book manuscript, her insightful comments and endorsement of this project. A huge thank you to Eric Lundgren for his enthusiastic response to my book proposal for the Forerunners series and for his warm support and encouragement throughout the stages of publication.

As ever I am indebted to the artists whose artworks have been the inspiration for *Out of Breath: Vulnerability of Air in Contemporary Art*. I would like to thank them for their comments and responses to my text and for their vital contribution to this book.

Thank you to my family, friends, and everyone who helped me navigate the last twelve months. Nicholas Minns's editing and comments have been invaluable, as have been the sharing of ideas, insightful conversations and much more.

This book is dedicated to all those who struggle for breath and to my parents who no longer breathe.

*(Continued from page iii)*

## Forerunners: Ideas First

Chuck Rybak
**UW Struggle: When a State Attacks Its University**

Clare Birchall
**Shareveillance: The Dangers of Openly Sharing and Covertly Collecting Data**

la paperson
**A Third University Is Possible**

Kelly Oliver
**Carceral Humanitarianism: Logics of Refugee Detention**

P. David Marshall
**The Celebrity Persona Pandemic**

Davide Panagia
**Ten Theses for an Aesthetics of Politics**

David Golumbia
**The Politics of Bitcoin: Software as Right-Wing Extremism**

Sohail Daulatzai
**Fifty Years of *The Battle of Algiers*: Past as Prologue**

Gary Hall
**The Uberfication of the University**

Mark Jarzombek
**Digital Stockholm Syndrome in the Post-Ontological Age**

N. Adriana Knouf
**How Noise Matters to Finance**

Andrew Culp
**Dark Deleuze**

Akira Mizuta Lippit
**Cinema without Reflection: Jacques Derrida's Echopoiesis and Narcissism Adrift**

Sharon Sliwinski
**Mandela's Dark Years: A Political Theory of Dreaming**

Grant Farred
**Martin Heidegger Saved My Life**

Ian Bogost
**The Geek's Chihuahua: Living with Apple**

**Caterina Albano** is reader in visual culture and science at Central Saint Martins, University of the Arts, London. She is the author of *Memory, Forgetting, and the Moving Image* and *Fear and Art in the Contemporary World.*